ROXY PAINE

FERMENT

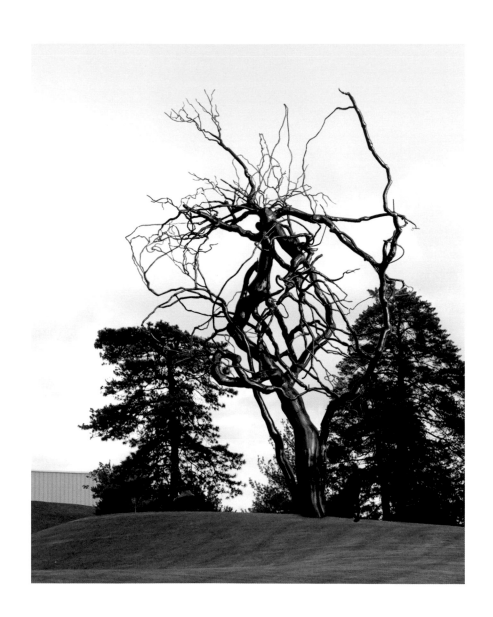

Dedicated Arbor Day, April 29, 2011

ROXY PAINE

FERMENT

Jan Schall, Editor

THE NELSON-ATKINS MUSEUM OF ART | KANSAS CITY, MISSOURI

Published on the occasion of the installation of Roxy Paine's **Ferment** in the Kansas City Sculpture Park at The Nelson-Atkins Museum of Art, Kansas City, Missouri, and the Museum exhibition, **Roxy Paine: Scumaks and Dendroids**, April 29–August 28, 2011.

This exhibition has been organized by The Nelson-Atkins Museum of Art. This exhibition is supported by Marti and Tony Oppenheimer, Oppenheimer Brothers Foundation, James E. C. and Elizabeth Tinsman, the Campbell-Calvin Fund and Elizabeth C. Bonner Charitable Trust for exhibitions, and the Rheta A. Sosland Fund.

Lenders to the exhibition

James Cohan Gallery, New York/Shanghai; John & Amy Phelan; the Collection of Anabeth and John Weil; and a private collector.

Library of Congress Cataloging-in-Publication Data
Paine, Roxy, 1966–
 Roxy Paine : Ferment / Jan Schall, editor. – 1st ed.
 p. cm.
 Published on the occasion of an exhibition held at the Nelson-Atkins Museum of Art, Kansas City, Mo., Apr. 29–Aug. 28, 2011.
 Includes bibliographical references.
 ISBN 978-0-615-43782-8
 1. Paine, Roxy, 1966– Ferment–Exhibitions. 2. Steel sculpture, American–Exhibitions. I. Schall, Jan, 1952– II. Nelson-Atkins Museum of Art. III. Title. IV. Title: Ferment.
 NB237.P17A64 2011
 730.92–dc22 2011002849

Cover: Roxy Paine, **Model for Ferment** (detail), 2010. Stainless steel, 54 x 43 x 38 in. Courtesy of the artist, Roxy Paine Studio, and James Cohan Gallery, New York

Frontispiece and page 85: Roxy Paine, **Model for Ferment,** 2010. Photoshopped image for **Ferment** installation

Project director and general editor: Jan Schall
Copy editor and proofreader: Fronia W. Simpson
Designer: Patrick Dooley
Typeset in Futura by Marie Weiler
Cover foil and embossing die: Olympic Graphics International, Kansas City, Kansas
Printed and bound by Lowell Press, Kansas City, Missouri

Contents

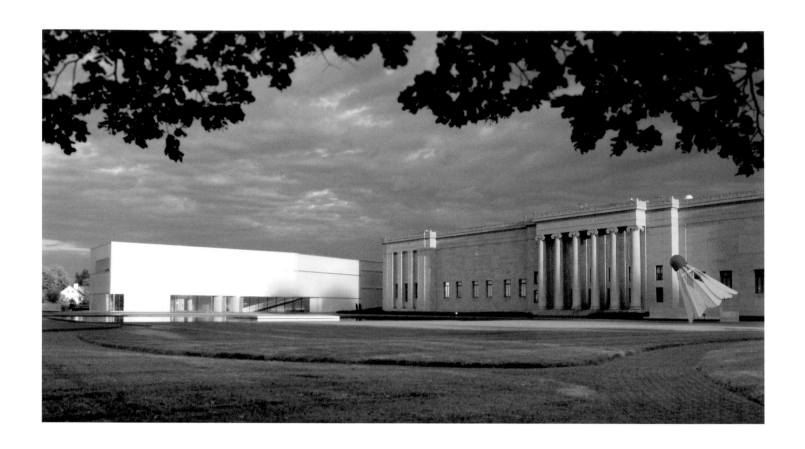

The Nelson-Atkins Museum of Art (north view). Nelson-Atkins Building, Wight and Wight, Architects, 1933; Bloch Building, Steven Holl, Architects, 2007. Photo: Mark McDonald

Foreword and Acknowledgments

The installation in the Nelson-Atkins's Kansas City Sculpture Park of Roxy Paine's fifty-six-foot-tall stainless steel sculpture, *Ferment*, marks a significant moment. It honors Martin Friedman, Director Emeritus of the Walker Art Center in Minneapolis, whose passion for sculpture can be felt throughout the Sculpture Park and within the modern and contemporary galleries of both the Nelson-Atkins and Bloch Buildings. As art adviser to the Hall Family Foundation, Martin worked with my esteemed predecessor, Marc Wilson, and especially with curators Deborah Emont Scott for the first decade and Jan Schall for the second to build our outstanding collection of modern and contemporary sculpture. Thanks to Martin's guiding vision, tireless energy, vast knowledge of the field, and personal friendships with artists, together with the extraordinary support of the Hall Family Foundation, twenty-two magnificent sculptures entered the Museum collection through the work of the Modern Sculpture Initiative. An additional fifty bronzes by Henry Moore, acquired by the foundation before the Initiative was launched, are also now part of the Museum collection. All are on view.

In the spring of 2009, after twenty years of incomparable service to the Hall Family Foundation and the Nelson-Atkins Museum, Martin retired. At the conclusion of a lovely dinner in his honor, he was presented with a fantastic gift: the opportunity to select one more great work of art for the Sculpture Park. That commissioned work is Roxy Paine's brilliant, freshly installed Dendroid, *Ferment*, which is the focus of this book, an exhibition, and a host of exciting programs.

The installation of *Ferment* also signals new beginnings. It is with great pleasure that we welcome this first grand addition to the Kansas City Sculpture Park since my arrival here in September 2010. We look forward to continued fruitful collaboration with the Hall Family Foundation, to future acquisitions and to more exciting projects and exhibitions. Roxy Paine's *Ferment* is a symbol of growth

and change, strength, and beauty. The Nelson-Atkins is honored to join the family of museums and sculpture parks throughout the world that are home to Paine's Dendroids. What an auspicious beginning!

A project of this scope requires the focus and dedication of many. Let me first express my sincere gratitude to those beyond the Museum's walls, whose contributions have made this installation and exhibition possible. Donald J. Hall's courage, belief in the power of art, and commitment to high ideals are evidenced, once again, in this most recent commission. Don, Chairman of the Board of the Hall Family Foundation, is supported by an astute board, by William A. Hall, President and Assistant to the Chairman of the Hall Family Foundation, and by current and former vice presidents Angela McClelland, Jeanne Bates, and Peggy Collins. We thank each of them warmly.

To Martin Friedman, we are deeply grateful. His knowledge, business acumen, and sense of humor have made the journey both rewarding and joyful. How fitting that his parting contribution to the Museum's Modern Sculpture Initiative should be the Hall Family Foundation's gift in his honor: Roxy Paine's *Ferment*.

I also wish to express thanks to the lenders to the exhibition *Roxy Paine: Scumaks and Dendroids*. Because of their great generosity, visitors to the Nelson-Atkins will have the opportunity to experience Paine's sculpture-making machine, *Scumak No. 2*, as it produces polyethylene sculptures. They will also be able to examine the *Model for Ferment*, *Model for Distillation*, *Model for Conjoined*, *Model for One Hundred Foot Line*, and *Model for Façade/Billboard*. Lenders are the James Cohan Gallery, New York/Shanghai; John & Amy Phelan; the Collection of Anabeth and John Weil; and a private collector.

The exhibition, *Roxy Paine: Scumaks and Dendroids*, accompanying catalogue, and programs are generously supported by Marti and Tony Oppenheimer, Oppenheimer Brothers Foundation, James E. C. and Elizabeth Tinsman, the Campbell-Calvin Fund and Elizabeth C. Bonner Charitable Trust for Exhibitions, and the Rheta A. Sosland Fund. We extend our warmest thanks to all for their enthusiastic support and generosity.

Clearly, none of this would exist were it not for the source of it all—the artist. Roxy Paine's quest to understand the interrelationship of nature and culture has resulted in a diverse and magnificent body of work that speaks on many levels.

At his studio in Treadwell, New York, Paine is ably assisted by Sheila Griffin, Office Manager; Ben Jones, Studio Manager; Sofia M. Paine, CAD Drawings & Consulting; Andrew Shook, Christopher Guardiano, Charles Orme, and Ross Caudill, Studio Assistants; and Ben Jones, Sheila Griffin, and Jeremy Liebman, Photography. Thanks are due to Vulkane Industrial Arts, fabricator of the trunk components for *Ferment*. We extend profound thanks to Paine and his entire studio for bringing *Ferment* into being and installing it in our Kansas City Sculpture Park. We are also grateful to the James Cohan Gallery in New York, especially to Jim Cohan, Jessica Lin Cox, and Elyse Goldberg, for working with us every step of the way—graciously providing images, information, and advice.

I am grateful to Donald J. Hall, Morton Sosland, Martin Friedman, and Jan Schall for their insightful essays and to Fronia W. Simpson, copy editor and proofreader; Patrick Dooley, designer; Marie Weiler, typesetter; and Payson W. Lowell and his staff at Lowell Press, printer. Their collective talents and expertise are eminently manifested in this beautiful exhibition catalogue.

At the Museum, the Roxy Paine *Ferment* project was led by Jan Schall, Sanders Sosland Curator of Modern and Contemporary Art, who also guided the exhibition and catalogue with characteristic energy and imagination. I am grateful to Jan and the entire staff of the Nelson-Atkins. Their commitment to excellence in matters large and small has ensured the success of this project. A special thanks to our project team: Dee Dee Adams, Elisabeth Batchelor, Emily Black, Tammy Bluhm, Michele Boeckholt, Beth Byers, Cindy Cart, Karen Christiansen, Margi Conrads, Lissa Cramer, Michael Cross, Cammie Downing, Christine Droll, Ann Erbacher, Kate Garland, Tim Graves, Barbara Head, Matthew Holgerson, Harland Hunt, Adam Johnson, John Laney, Melissa Kleindl, Kathleen Leighton, Janet Mark, Mendel Martin, Brad Masuen, Julie Mattson, Helen Meyer, Mark Milani, Christine Minkler, Hillary Nordholm, Jodi Olson-Kidney, Susan Patterson, Clint Paugh, Kerry Peak, Joe Rogers, Lisa Schlagle, Sarah Hyde Schmiedler, James Schwartz, Stacey Sherman, Shannon Stone, Tim Terfler, Bob Tolnai, Melissa Tone, Mona Vassos, Steve Waterman, Brandon Wilcox, Toni Wood, Amanda Zeitler, and Mark Zimmerman.

Julián Zugazagoitia
Menefee D. and Mary Louise Blackwell Director & CEO
The Nelson-Atkins Museum of Art

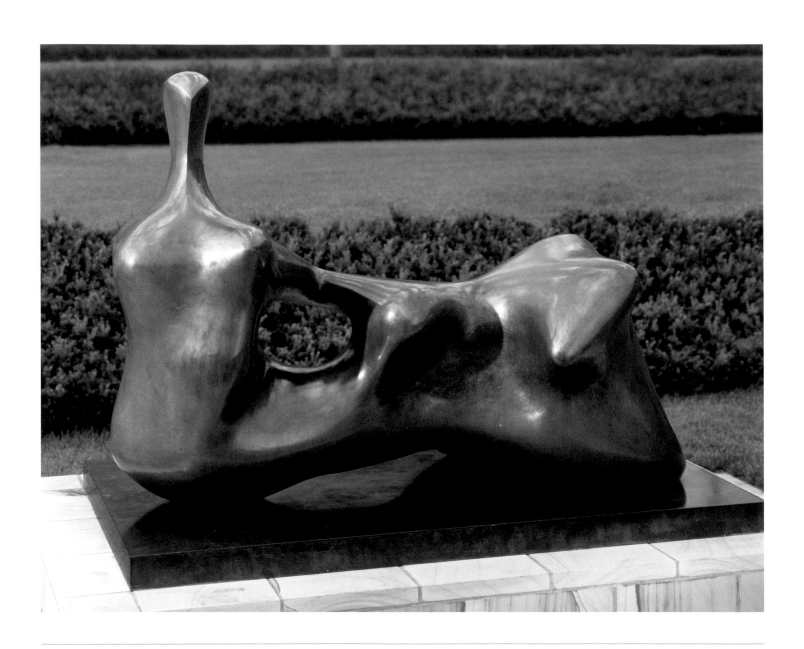

Henry Moore, *Reclining Figure: Hand*, 1979

Growing the Kansas City Sculpture Park

Donald J. Hall

Working with an outside consultant, Seymour Slive, the Hall Family Foundation determined in 1985 that collecting monumental modern and contemporary sculpture would be uniquely beneficial for The Nelson-Atkins Museum of Art and for Kansas City. We felt this was true for three reasons: (1) Few museums have extensive grounds in an urban setting; (2) Because the Nelson Trust limits acquisition of modern art, this was an area of the Museum that needed to be enhanced; and (3) Because of scale, monumental sculpture is difficult to display and thus does not command the price of modern paintings.

These thoughts were in our minds when the Ablah collection of more than fifty Henry Moore sculptures became available in 1986. Of course, most important, we and Marc Wilson admired Henry Moore and knew the collection would enhance Moore's *Sheep Piece*, which had been on the Museum lawn for many years.

Morton Sosland later introduced us to Martin Friedman, Director Emeritus of the Walker Art Center, whom we engaged to help advise further acquisitions. Under Martin's guidance, the Modern Sculpture Initiative was launched as a vision and a plan for the Museum: the foundation would acquire sculptures and place them on loan at the Nelson-Atkins. Martin's counsel and his connections have been invaluable. He was instrumental in every acquisition we made after the Moores and in the programming and design of the Sculpture Park.

Martin had developed a wonderful, albeit different, sculpture garden in Minneapolis. His knowledge of modern and contemporary sculpture and his relationships with artists were critical to our success. The collection expanded, thanks to Martin's ability to find, commission, and purchase the best works by great modern and contemporary artists. Outdoors in the Park are fine sculptures

by such artists as Magdalena Abakanowicz, Tony Cragg, Walter De Maria, Mark di Suvero, George Segal, and Judith Shea. Indoors are major works by Constantin Brancusi, Alexander Calder, Alberto Giacometti, Sol LeWitt, Isamu Noguchi, and others.

Perhaps the defining moment that brought the Sculpture Park into people's consciousness was the Sosland family's gift to the Museum of Claes Oldenburg and Coosje Van Bruggen's *Shuttlecocks*. It created a stir because of its location, but it also made people talk and think and appreciate the great works in the Park. Today, *Shuttlecocks* are a community icon.

Most important, Martin's enthusiasm for the Modern Sculpture Initiative was infectious to me and to our board. His passion and excitement for art, the artists, and the Nelson-Atkins positively shaped a solid twenty-year relationship. The progress achieved by Martin was a result of his expertise, persistence, patience, and wonderful ability to kindly yet powerfully influence the advancement of the Sculpture Park.

We also owe tremendous thanks to the Nelson-Atkins for its leadership of the Modern Sculpture Initiative. The project was embraced from the beginning and cultivated with forward vision. The Nelson's curators, together with Martin, have developed one of the world's most recognized collections of modern sculpture. The staff members who care for the sculpture are also to be commended. On a daily basis the monumental outdoor works are cleaned, protected, and lovingly cared for by expert, dedicated hands. The Museum's ongoing publishing and education efforts and activities for the Sculpture Park contribute to its fine reputation and help us share the collection with the world. The modern sculpture collection now belongs to the Museum, and we continue to support new sculpture acquisitions.

It was Martin who introduced us to the stunning work of the young artist Roxy Paine. Paine's sculpture *Ferment* will join other great sculptures and add to the luster and quality of the Park. Because it is a dramatic piece in scale, complexity, and appearance, we expect it will create the same excitement as the Moores, the *Shuttlecocks*, and others. We hope for this excitement not just for the Museum and visitor but for Martin Friedman, whose energetic hand and fertile mind are evidenced in the sculptures installed in both the Park and the Museum. He is a treasure, and Kansas City has benefited enormously from his involvement.

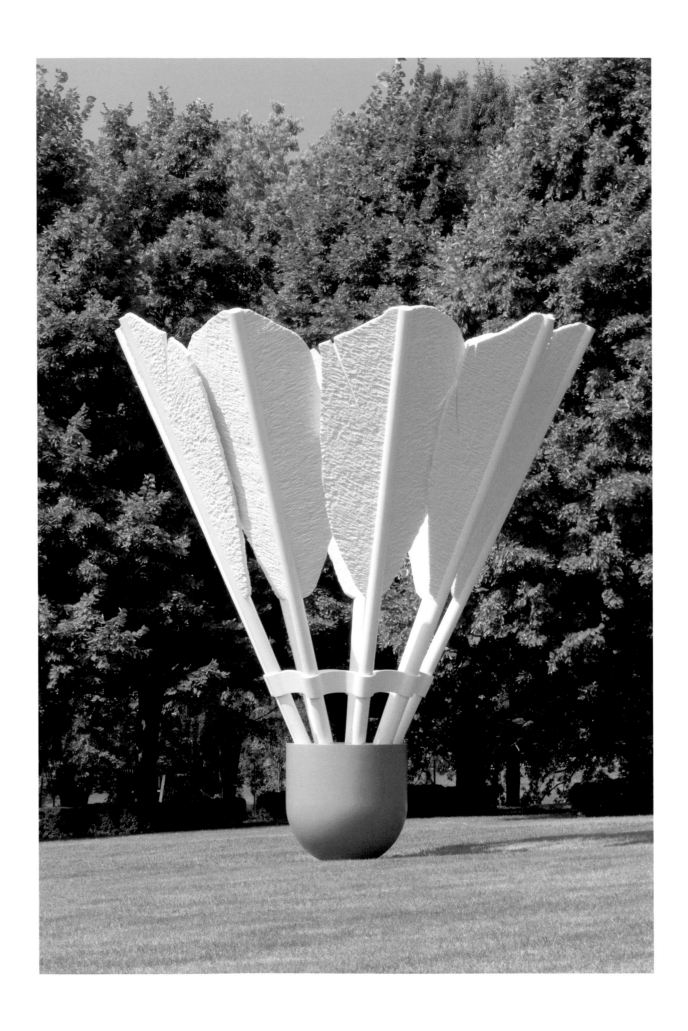

The Modern Sculpture Initiative and Roxy Paine

Morton Sosland

As a longtime member of the board of the Hall Family Foundation and as a deeply committed "friend" of The Nelson-Atkins Museum of Art, I often found myself over the years discussing with my fellow board members and foundation staff how best to help the Museum become an even stronger and better institution than it already was. It was I who thought that the Museum could pursue a specific collecting focus. It was in the midst of these conversations that someone recalled that the first trustees of William Rockhill Nelson's estate turned to the art history department at Harvard University to help them establish the original collection. Since that approach had worked very well half a century earlier, why couldn't it happen again now? That led to some inquiries at Harvard as to who could provide the foundation with the sort of guidance it wanted.

The Harvard professor recommended to us was Seymour Slive, a highly regarded specialist in the work of Jacob van Ruisdael, the great seventeenth-century Dutch landscape painter. Even though his field did not seem to match what we in Kansas City needed, we were willing to give him a try. And what a success it was! Bill Hall, the foundation's president, met with Professor Slive in Cambridge and reported that Slive urged the Hall Family Foundation to focus on modern sculpture. Slive pointed out that this particular kind of art was not represented in the Nelson-Atkins collection and that high-quality objects could be bought at relatively reasonable prices. The absolute perfection of this recommendation is evidenced by how the Museum, with the support of the Hall Family Foundation, has amassed a distinctive and outstanding group of modern sculpture. The superb Kansas City Sculpture Park, a fulfillment of this collecting aim, reminds us of how important this effort has been to the growing recognition of the Nelson-Atkins internationally.

Claes Oldenburg and Coosje van Bruggen, *Shuttlecocks*, 1994

We at the Hall Family Foundation also realized that none of us had the experience or the skill to put into practice what had now been embraced as the Modern Sculpture Initiative. Further, the Museum did not, at that time, have a curator trained in this field. Discussions about how best to proceed brought to my mind someone my wife, Estelle, and I had met on several occasions at the Walker Art Center in Minneapolis.

Knowing that Martin Friedman, the highly regarded director of the Walker, was about to retire, the suggestion was made that the Hall Family Foundation retain him as adviser in the field of modern sculpture. With Martin at our side, we learned that the only mistake we could possibly make was to let his enthusiasm and drive overwhelm our budgets. Every piece acquired as part of the Modern Sculpture Initiative was either found or vetted by him. The result is stunning.

When the decision was made to create the Kansas City Sculpture Park to provide appropriate space for the growing collection, first for the display of the Henry Moore pieces and later for other acquisitions, I pressed hard to have the Park named to honor either Don Hall's parents or his family. He said No to this, as he did not want his family's name on the Park, believing that it might discourage others wishing to contribute to it.

As the Kansas City Sculpture Park was nearing completion, my brother Neil and other members of our family responded enthusiastically to my proposal that we commission a piece of sculpture to be installed in the Park, and that we should do that close to 1990, the year that marked the centennial of our grandfather Henry Sosland's settling in Kansas City. Who should do the sculpture was quickly settled when I recalled an earlier moment when we had talked with Claes Oldenburg about doing a piece for the Museum's lawn. In trying once more to have a piece by Oldenburg at our Museum, I called Martin, asking him to test Claes's interest. The answer was a positive one.

We might say that the rest is history. Today, the four *Shuttlecocks* are arrayed on the Museum lawn as if they had been there forever. The controversy created by this sculpture is less important to us than our never wavering in our intent to complete the project as our tribute to our city, to the Nelson-Atkins, and to the wonders that the Hall Family Foundation has brought all of us.

A Dendroid Grows in Kansas City

Martin Friedman

The current addition of Roxy Paine's *Ferment* to our Kansas City Sculpture Park represents yet another generous commitment on the part of the Hall Family Foundation. Commissioned at the request of the foundation's esteemed retiring art adviser, Martin Friedman, and presented to the Nelson-Atkins in his honor, this gift celebrates Martin's spirited vision and points to a bright future for the Museum and Park.

Although Roxy Paine's towering stainless steel sculptures re[semble] trees, the artist thinks of them as Dendroids. Dendroids? Well, yes. Acco[rding to] *Webster's*, "dendroids" are branching structures, treelike in form and p[attern of] growth. The term also applies to the system of blood circulation and neural [

Roxy Paine's Dendroids have begun to dot the continent. They also tu[rn up in] venues as far away as Israel and Australia. There are twenty-five of them [includ]ing the latest, *Ferment*, a commissioned work for the Kansas City Sculp[ture Park] at The Nelson-Atkins Museum of Art. *Ferment* is the subject of this ess[ay, but a] little history first.

The first of Paine's Dendroids, titled *Impostor* and made in 1999, was [Swedish-] born in that it was commissioned by the Wanås Foundation Sculptur[e Park, in] southern Sweden. The first American Dendroid sculpture, *Bluff*, was in[stalled in] Central Park, in New York City, with support from the Public Art Fund [and was in] the 2002 Whitney Biennial. Each Paine Dendroid differs in configur[ation from] its predecessors, though they share basic attributes—trunks, branches, t[wigs, and] leaflessness. They may suggest known tree species but are mostly riffs [

At this point, full disclosure: *Ferment* has personal meaning for me. Aft[er I retired] from the position of director of the Walker Art Center, in Minneapolis, [in 1990,] the Hall Family Foundation, a major supporter of The Nelson-Atkins M[useum of] Art, asked me to serve as a consultant to the Museum by building it[s sculpture] collection. I enjoyed thinking of myself as the Nelson-Atkins's yardm[aster, whose] job it was to find and commission sculptures for the Museum's twen[ty-two-acre] Kansas City Sculpture Park. Among my projects was assisting the S[osland fam]ily in the commissioning of Claes Oldenburg and Coosje van Brugg[en, his] wife and collaborator, to create a large-scale sculpture they named *Sh[uttlecocks.*]

Roxy Paine, ***Drawing for Ferment***, 2009

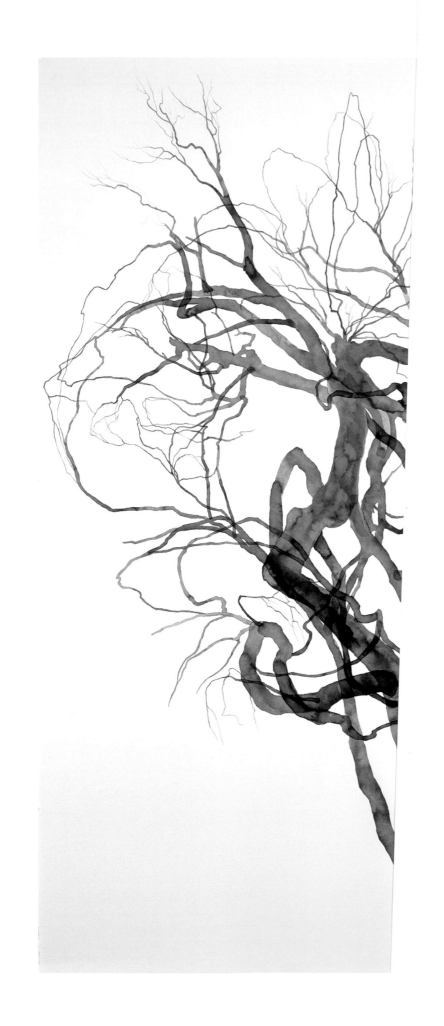

Its four gigantic badminton birdies were distributed on the front and back lawns of the Museum's original 1933 Beaux Arts building. Their advent in 1994 virtually divided the town into opposed camps of supporters and detractors. Younger visitors and not a few older ones immediately took to these feathered aliens. There were also those among the public who were scandalized by the badminton birds' placement on what they conceived to be holy ground. The editorial page of the *Kansas City Star*, no less, led the attack, but to little avail. The attack backfired, and its effect was to heighten interest in this four-part sculpture. Soon, *Shuttlecocks* became Kansas City's must-see tourist attraction, its Eiffel Tower.

The Kansas City Sculpture Park had been constructed a few years before my association with it began. The impetus for it was the acquisition of a group of Henry Moore bronzes from a regional collector. The largest of these were installed in the Park, the rest in the Museum. Subsequently, I participated in the purchase of sculptures for the indoor galleries, including works by such eminent artists as Anish Kapoor, Martin Puryear, and Oldenburg as well as George Segal's *Rush Hour*, a group of bronze pedestrians now situated at the juncture of the Nelson-Atkins Building and the Bloch Building, the 2007 addition by Steven Holl.

On the north side of the original building is Walter De Maria's *One Sun/ 34 Moons*, a work with an expansive, slightly domed, gold-leafed rectangle suggesting the curvature of the sun that seems to float in the reflecting pool. On the south side, Judith Shea's five-part bronze sculpture, *Storage*, presents variations on representations of the female form: both realistic and semiabstract. The Park, with its formal terraces, allées, and roundels, was designed by the distinguished landscape architects Dan Kiley and Jaquelin Robertson. Among the many works that I helped acquire for the Park are *Three Bowls*, a monumental trio of cedar bowls by Ursula von Rydingsvard; *Standing Figures (Thirty Figures)*, a squadron of headless bronzes by Magdalena Abakanowicz; a group of five geometric elements—sharp-edged abstractions of ice crystals in white painted metal by Sol LeWitt; and *Rumi*, a soaring orange-painted steel girder sculpture by Mark di Suvero.

To commemorate my twenty years of service to the Hall Family Foundation and the Nelson-Atkins, I was given an unprecedented farewell gift. Not a gold watch

or matching luggage for a trip around the world, but a gift that would remain in Kansas City long after my departure. At a farewell dinner in late 2009, the Hall Family Foundation informed me that I could select or commission a work by any artist I chose for placement in the Kansas City Sculpture Park—within reason, of course. My choice was a stainless steel Dendroid by Roxy Paine, for whose sculpture I have long been an advocate.

Roxy and I first met when he had a studio on Berry Street in the Williamsburg section of Brooklyn in the mid-1990s, well before he was making Dendroids. He looks today pretty much the same as he did then. Tall, with lanky, regular features, close-cropped hair, and long sideburns, he could be a westerner, a bit of the cowboy. Though he has spent considerable time in New Mexico and Colorado, he hails from New York City, where he was born in 1966. In conversation he inserts lots of pauses and time out for reflection, especially when answering questions about the various technologies he employs.

The reason for my studio visit was to see a computer-operated painting machine he had invented, a structure consisting of a bar to which a canvas was attached that was periodically dipped into a vat of viscous white paint. After each dip, more paint adhered to the canvas. Roxy had eliminated the middleman—the painter. The machine ran on a program he had devised for a laptop computer. I also remember seeing sculptures that at first I took to be real mushrooms. These were casually deployed on the floor and on walls.

When the Museum agreed to my choice of artist, I contacted Roxy and his dealer, James Cohan, to give them the good news and ask how we should begin. The process was relatively simple, I learned. Roxy would produce drawings showing several possibilities. He did not design sculptures to be site-specific; they could work equally well in several locations. One of his designs would be the basis for a sculpture commissioned by the Museum. Having accepted our invitation to create a work, Roxy set about making drawings for it. One of these, an elegantly realized portrayal of a treelike form with an angular trunk and branches, an early favorite, was rendered in delicate ink washes. Its eloquence and ineffability recalled the fragility of a Japanese ink drawing, and its title was *Ferment*. The motion implied by its title would be evident soon enough, in the ensuing model for the piece.

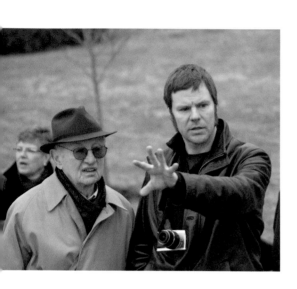

Siting **Ferment**, March 14, 2010. From left:
Jeanne Bates, Martin Friedman, Roxy Paine.
Courtesy Shirley Harryman

The completed sculpture, Roxy said, would be some sixty feet high. When I saw the drawing at his house in Brooklyn near the Williamsburg Bridge, I also saw drawings for other future projects, some delineated in paint, others in ink. There was a delicacy and a tension about the drawing for *Ferment* that especially attracted me. It was at once precise and forceful, even though it consisted of thin, overlaid washes that hinted at the volumes of a sculpture.

However volumetric, the tree depicted in the drawing is seen from a single viewpoint. Roxy would make a model in order to work out the Dendroid's complex configuration that would vary drastically as the viewer walked around it. So detailed were Roxy's stainless steel models that every branch would appear with exactitude. Employing a scale of one inch to one foot, the model would be made at Roxy's studio in Treadwell, in upstate New York, near Albany.

The drawing was sent to The Nelson-Atkins Museum of Art, where it attracted considerable enthusiasm from the Museum staff and Hall Family Foundation. The next step was to determine the placement of the finished Dendroid that the model foreshadowed. On March 14, 2010, soon after the drawing arrived at the Museum, Roxy, James Cohan, and I flew to Kansas City to look over various sites in the Sculpture Park. It was a gray and misty day; in fact, there was a slight drizzle. Not the most propitious conditions in which to haul a drawing around. Not to worry; Roxy and James assured me that the layers of the framed drawing's cardboard were well sealed. Though unconvinced, I was obliged to go along. With the drawing in hand, the search for the sculpture's location began. True, Roxy does not think site specifically when conceiving his sculptures, but, like every artist, he has a strong interest in how and where they are shown. That day our objective was to select the ideal site.

It was humid enough to give me pause, as James Cohan, Museum staff members, and, at times, Roxy held the drawing so that the rest of us could try to envisage a stainless steel Dendroid in its place. This took a great deal of imagining, considering the disparity in size between drawing and finished sculpture. We took turns toting the drawing around the Park, pausing at different sites and holding it up for the others to imagine a tall, silvery Dendroid in its place. It was carried from one site to another so it could be seen against various backgrounds. The improbable scene of the drawing being rushed about and tested in various settings had a dash of slapstick about it. It reminded me of an old Mack Sennett

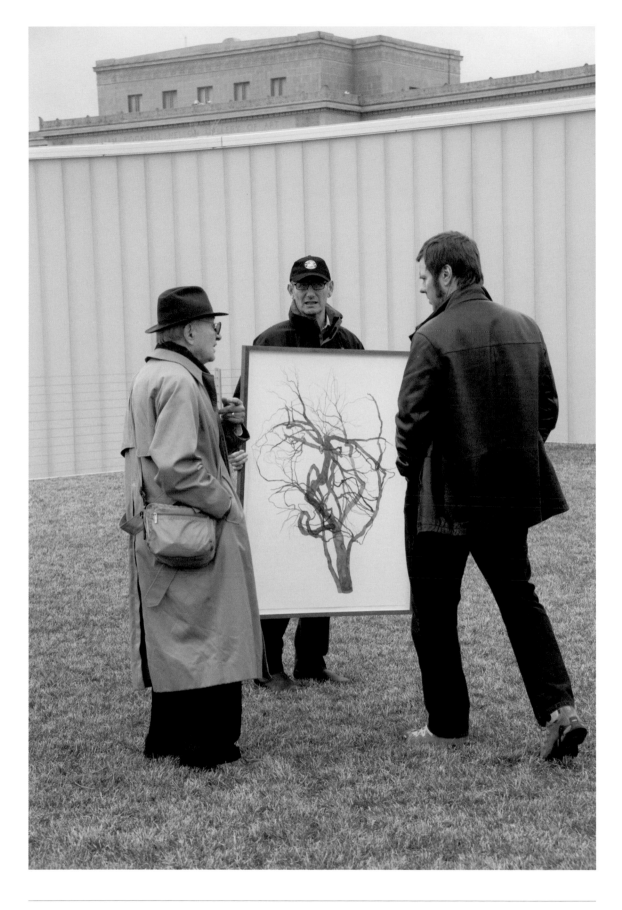

Siting *Ferment*, March 14, 2010. From left: Martin Friedman, James Cohan, Roxy Paine.

Courtesy Shirley Harryman

movie. Despite my concern about the drawing being toted about so casually, Roxy was not deterred. His cheering section, which we were, followed him from one end of the spacious Park to the other, eagerly awaiting his decision.

Though that decision would be his, each member of the entourage had his or her favorite site in mind. All agreed that there were certain areas in the landscape that would simply not work. For example, one too close to the 2007 Steven Holl addition to the Museum, with its cladding of thick, translucent glass planking (glamorous when illuminated from within at night but silvery gray by day), had its drawbacks. The stainless steel of the Dendroid and the silvery grayness of the building would not be a happy combination. Rather, the majority favored a site well away from both the limestone-clad original Museum and the recent addition to it. A number of us gazed longingly at a knoll east of the Park's formal central allée, which would provide the sculpture with a more naturalistic setting. Ultimately, Roxy came to that conclusion himself. The knoll was high and isolated and provided a background of dark evergreens against which the sculpture would shine.

The site now determined, fabrication of *Ferment* began at Roxy's studio. Eager to see how things were progressing, in June 2010 James Cohan drove Julián Zugazagoitia, the newly appointed director of The Nelson-Atkins Museum of Art, my wife, Mickey, and me to Roxy's studio in Treadwell to check on the progress of *Ferment*. There, Roxy and his crew were in the midst of forming sections of *Ferment*, welding and fitting limbs and branches together, some working in a high-ceilinged industrial space, others on a large concrete pad behind the studio. Treadwell is about 160 miles from New York City, a three-and-a-half-hour drive. The road to Treadwell bends and threads through picturesque landscape, and Treadwell itself looks like the summer vacation country that it is, with rolling hills, crystal-clear lakes, and no shortage of real trees. We were met by Roxy's wife, Sofia, carrying the couple's smiling child, and were ushered into what looked like a vintage farmhouse. The house, once part of a dairy farm, dates from 1870 and has undergone extensive renovation since 2002, when Roxy acquired it. He spends about 70 percent of his time working on projects there and is joined periodically by Sofia and baby Laila.

During lunch, Roxy and I talked about his work, and the subject of trees as Dendroids dominated. But why trees? I asked. Did he have some special affinity

for them as shapes or symbols? Not really, he replied. What was important was their configuration. He compared their branching effect with that of other forms in nature, mushrooms, for example, a theme that has long obsessed him. His sculptures of mushrooms are virtual simulacra of the real, growing things. Even more fascinating to him than their varying shapes and patterns are the systems that sustain them. Trees, whether a giant sequoia or a dwarf bonsai, embody the same principle: a complex of linear forms evocative of the pathways of nerves and circulation. Roxy describes these forms as Dendroids, as expressions of the vital growth that informs all of nature.

Though he dwells on the idea of growth in the natural world, crediting it as the core of his art, it is not as though his mechano-trees are without art historical ancestry. Trees, whether rendered naturalistically or abstractly, have since antiquity been favored subjects for artists. Whether the Tree of Life, an all-embracing theme in Middle Eastern iconography, the central theme of the French Barbizon artists, the emotion-wrought interpretations of Vincent van Gogh's cypresses in the moonlight, or Fernand Léger's cool, tubular translations of them in latter-day Cubism, trees have been essential to artists' visions of the world. Of the few artists cited, Léger's trees might best qualify as the ancestors of Roxy's. I am fairly certain that such analogies are far from Roxy's mind, but they are nonetheless somewhat inevitable. Roxy's invented trunks and spreading branches, for all the detachment they project, are decidedly poetic statements.

After lunch, we toured the house, and the first space we entered was what Roxy calls his drawing room, its walls covered with sketches in pencil and blue water-color washes. These were future projects, he explained. In addition to renderings of entire trees, some drawings were of tangled branches. Others suggested plumbing diagrams overlaid by parts of trees. After leaving the drawing room, we walked to a vast storage space filled with piles of stainless steel cylinders ranging from small and relatively lightweight to enormous, hard-to-lift ones. How anyone could keep track of these stacks of cylinders was a mystery, but a chart on the wall identifying groups of these materials and their locations was reassuring. Some of the pipes were pre-bent: their undulant forms were ready for incorporation in *Ferment*.

Each worker in Roxy's six-man studio in Treadwell had a reproduction of the drawing above his workbench and thus had ready reference to the part of the

Dendroid he was concentrating on. Making the model is largely a leap of faith. Every effort is made to use the juncture points that appear in the drawing, but there is obviously plenty of room for improvisation.

The stainless steel model for *Ferment*, which was five feet high, was perched on a makeshift pedestal on the concrete pad. Next to it was a micrometer that the welders used to measure the thickness of the model's tubing in order to find large-scale equivalents for the final piece. Attached to the model at various points were tabs of colored paper, which provided the welders with information about each part of the structure. Also attached to the model were small elements that, in their scale, looked like protruding sticks. These vertical tabs attached to branches were temporary directionals that would aid the workmen when it came time to assemble the big Dendroid. There were also a few conceits in the model, one of the men pointed out to me. Metal arrows, their tips pointed away from the massive trunk, were attached to the Dendroid at various points. Roxy did not explain their significance to me, and when I asked the workmen, they merely smiled.

Scattered along the edges of the concrete pad that served as the outdoor workplace were completed sections of *Ferment* that would ultimately be combined to form the whole Dendroid. Keeping madness at the door, says Roxy, is half the battle. The object, he said, was not to be overwhelmed by the masses of material and logistics of fastening them together. Parts of the Dendroid are laid out on the floor at various places in the studio, some partially welded, others ready for that process, small into large.

How would *Ferment* get to Kansas City for its April 2011 opening, I asked? Roxy explained that the disassembled pieces would travel on flatbed trucks, and then he and his crew would follow, to put it together in the Kansas City Sculpture Park.

There is nothing like a firsthand look at the scattered-about components of a Roxy Paine Dendroid to appreciate its complexity. The next time I would see its components would be in Kansas City, where Roxy and his crew would painstakingly assemble them, with the aid of forklifts, cherry pickers, and scaffolding, into a new totality, the majestic *Ferment*.

A different version of this article was first published in *Art in America*, October 2010.
Courtesy BMP Media Holdings, LLC.

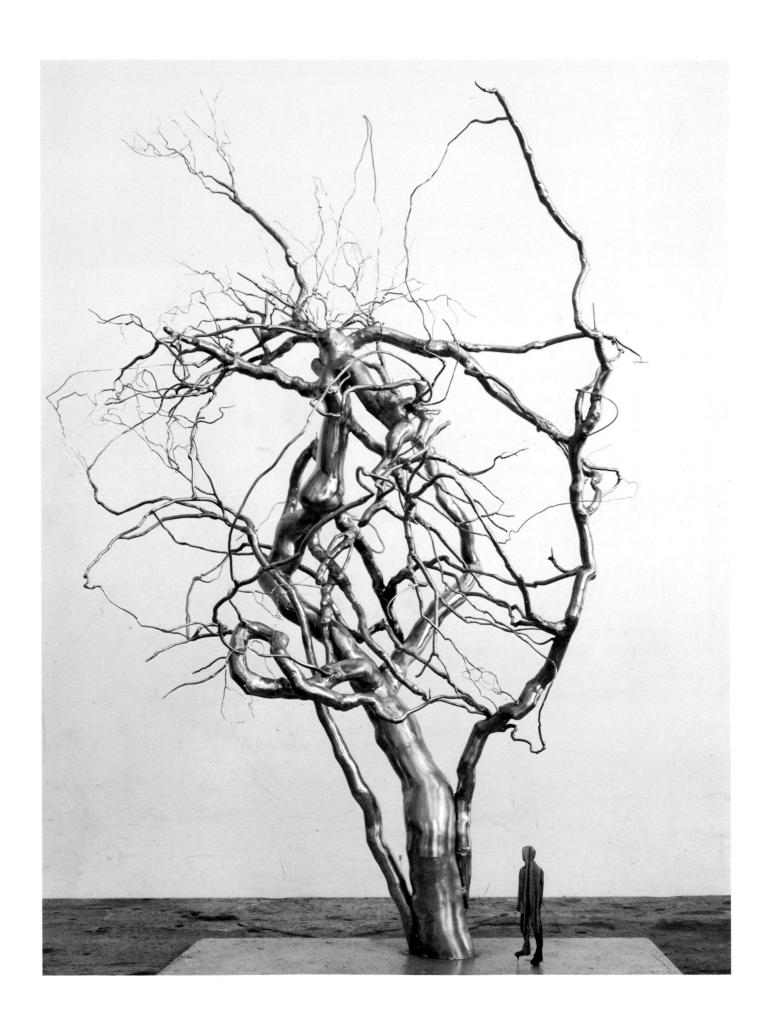

Ferment in Context

Jan Schall

Connections

Roxy Paine's *Ferment*, like the Dendroids that preceded and followed it, is a marvel of artistic vision and precise engineering. Rooted deep in the earth and anchored firmly to solid bedrock, *Ferment* rises fifty-six feet into the air, its silver branches scraping and mirroring the sky. Barren of leaves, it exists in a state of perpetual winter—naked and exposed to the ravages of wind, rain, snow, and ice but also to soft spring breezes, golden summer sun, and misty autumn fogs. The elegant lines of its architecture soar, arc, and twist, alternately thickening and thinning, as they disappear against the sky or, tangled, return toward the Earth.

Existing in space while bearing witness to the passage of time, *Ferment* is situated atop a natural promontory in the southeast section of the Nelson-Atkins's Kansas City Sculpture Park. Paine selected this site for its elevation and visibility but especially because it met two of his chief site criteria for the Dendroids: an open clearing and a framing bank of trees. Here, they are evergreen trees—primarily mature Scotch pines. Visitors traversing the winding pathways of the Sculpture Park will experience *Ferment* fully in the round. Beyond the Park, east- and west-bound drivers on Emanuel Cleaver II Boulevard need only glance northward to have a clear view of the sculpture. The imposing presence of *Ferment* also will invite Frisbee players, sunbathers, and picnicking families in Theis Park (to the south) to cross the boulevard for a better look.

Close to *Ferment* are Henry Moore's *Large Torso: Arch*, *Large Totem Head*, and *Reclining Connected Forms*, three monumental bronze sculptures that reference the human body. A little farther away is Moore's *Sheep Piece*, so named for the sheep that liked to rub against it in the pasture surrounding his home in southern England. Just beyond that is another work by Moore, *Large Interior Form*, an

Roxy Paine, **Model for Ferment**, 2010

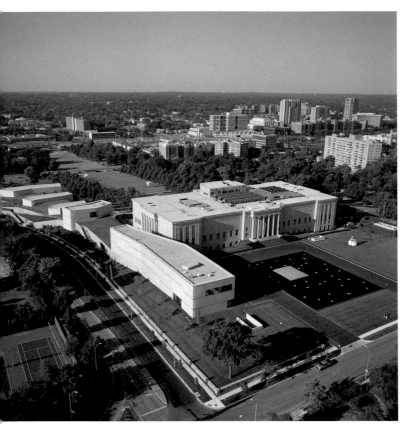

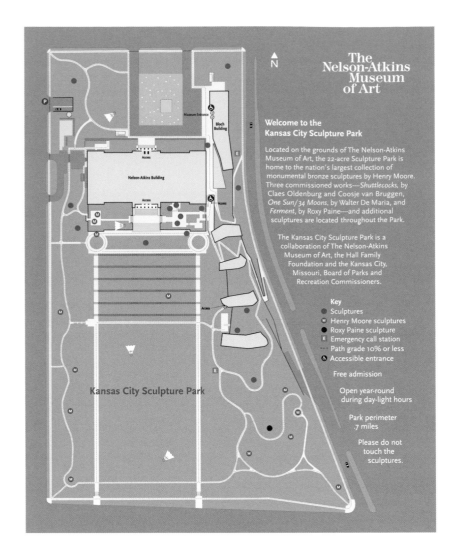

The Nelson-Atkins Museum of Art and Kansas City Sculpture Park, north view. © Timothy Hursley

top right: Site plan, Kansas City Sculpture Park, The Nelson-Atkins Museum of Art, 2011

right: Rick Howell, *Ferment Installation Rendering*, Kansas City Sculpture Park, 2011

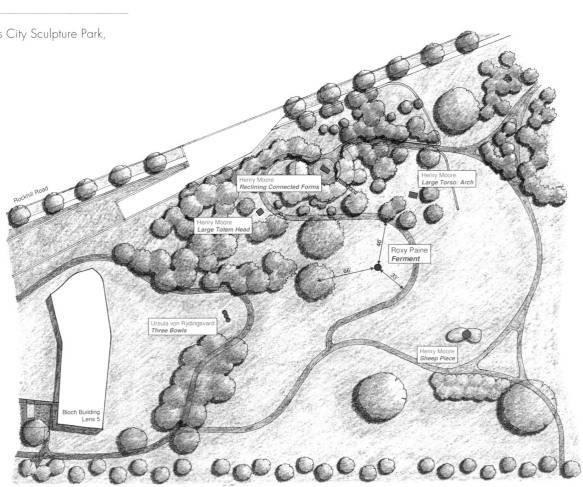

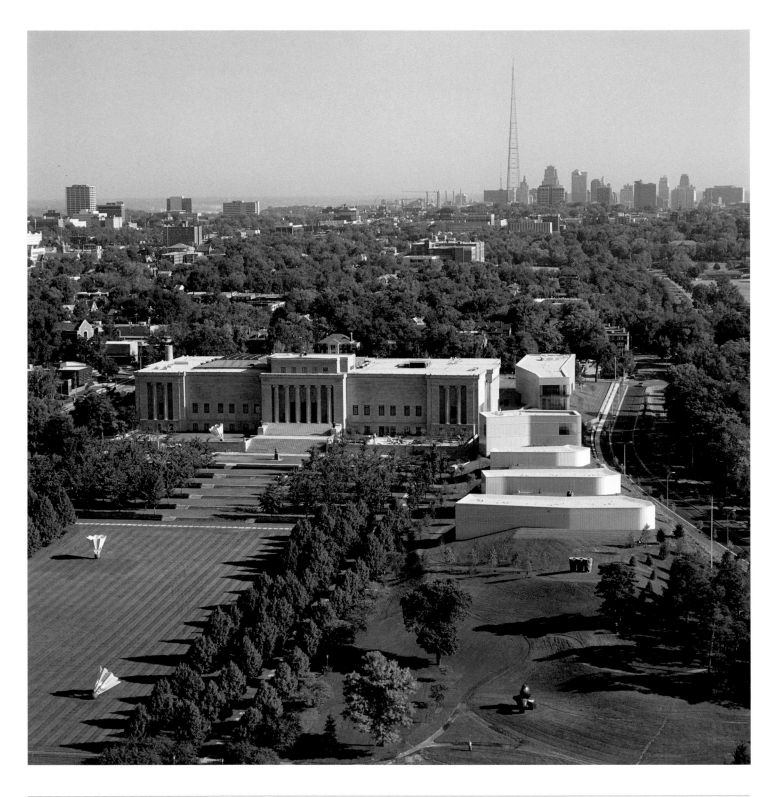

The Nelson-Atkins Museum of Art and Kansas City Sculpture Park, south view. © Timothy Hursley

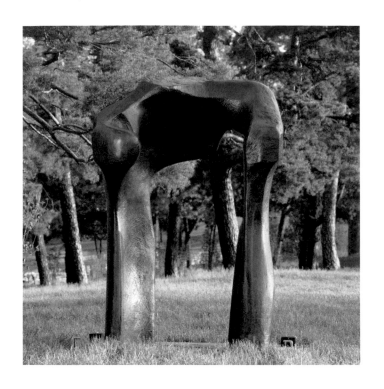

Henry Moore, *Large Torso: Arch*, 1962–63

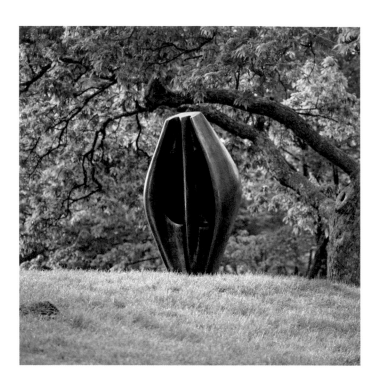

Henry Moore, *Large Totem Head*, 1968

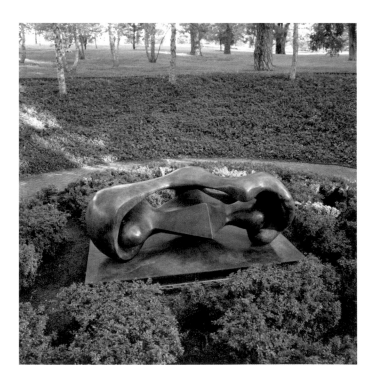

Henry Moore, *Reclining Connected Forms*, 1969

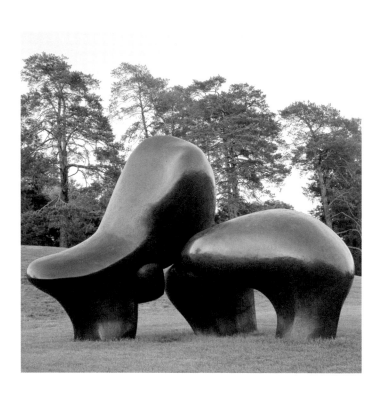

Henry Moore, *Sheep Piece*, 1971–72

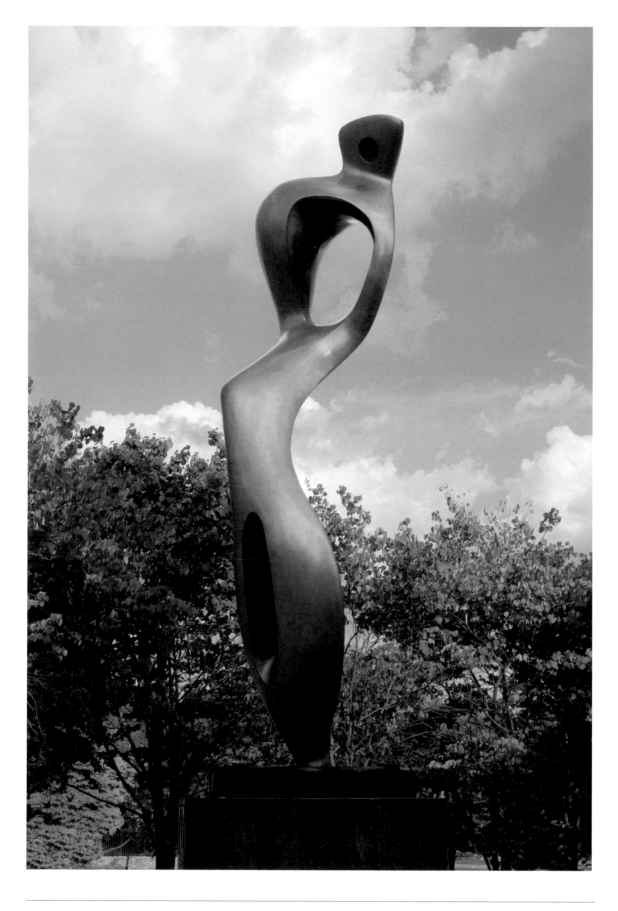

Henry Moore, *Large Interior Form*, 1981

alone in the vast, silent sublimity of nature and bound by its endless cycle of life and death.

Structurally, *Ferment*'s nearest relative in the Sculpture Park is George Rickey's *Two Planes Vertical-Horizontal*. Like Paine's towering Dendroid, Rickey's sculpture is pristine and constructed of welded stainless steel. Both reflect sunlight in blinding flashes. Whereas the surface of *Ferment* is generally smooth, that of *Two Planes* is calligraphically brush-textured. Rickey's sculpture is a kinetic work. Its two planes, balanced exquisitely atop a slender, vertical, eighteen-foot-tall support, are set in motion, like leaves, by passing winds.

A beautiful symmetry accompanies the arrival of *Ferment* at the Nelson-Atkins, for it was in 2001, precisely ten years ago, that Roxy Paine's artist residency at Grand Arts, in Kansas City's Crossroads Art District, culminated in an extraordinary exhibition of his fungus Replicants, his *PMU [Painting Manufacture Unit]*, and the resultant machine-made paintings, or *PMUs*. Grand Arts, funded since 1995 through the generosity of the Margaret Hall Silva Foundation, encourages the development of bold, innovative projects by emerging and midcareer artists by providing work space, equipment, and all manner of support.

In 2003 Paine's work was included in the group exhibition *UnNaturally*, presented at the Kansas City Art Institute's H & R Block Artspace. It has taken nearly a decade to bring Roxy Paine's work back to Kansas City, but the wait was worth it. The Nelson-Atkins's Kansas City Sculpture Park has been greatly enriched by this newest work of art: *Ferment*.

Contradictions

Roxy Paine's work can be understood, largely, as an investigation of the contradictions, dichotomies, and complementarities that define the world in which we live. His Replicants—meticulously cast, assembled, and painted sculptures of fungi, poppies, poison ivy, weeds, and rotting tomatoes—present convincing trompe l'oeil visions of natural organisms. These are not the robust roses, trumpeting lilies, or sweet violets of seventeenth-century Dutch still-life paintings, however. Instead, they represent "bad" nature, those organisms

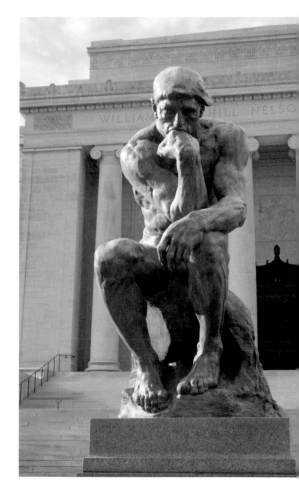

Auguste Rodin, **The Thinker**, 1880

Charles Heit and Kenny Mowatt, **Totem Pole**, 1977

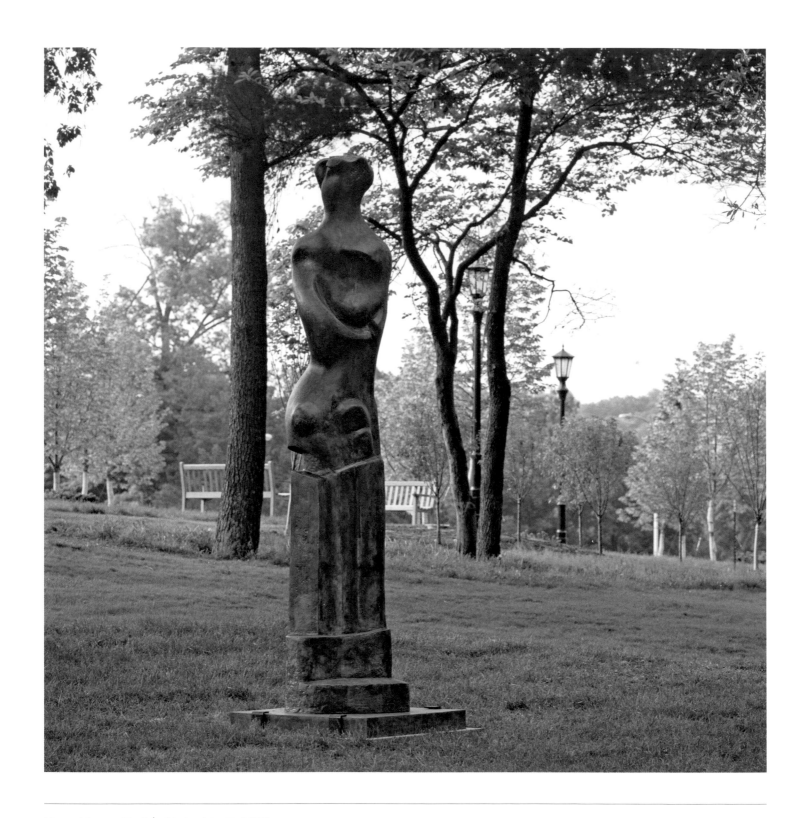

Henry Moore, *Upright Motive No. 9*, 1979

decried by gardeners, landscapers, and our order-obsessed human culture, in general, as dangerous, poisonous, invasive, undesirable, and decadent.

Hyperreal, though completely artificial, these forms remind us that all life is cyclical. There is birth, growth, fruition, decline, death, and regeneration. Paine has observed that "in terms of the cycle, fungus is necessary. They decompose vegetable matter first, then the bacteria and microbes come in and can work with that material. I've read that without fungus we'd have a mile deep of vegetable matter everywhere because all the dead trees and vegetation would never break down."[1] It follows that without the decay and decomposition of organic matter, nutrients contained within that matter would never enter and enrich the soil; never enable new plant life to sprout, grow, and bear fruits; never sustain animal and human life. Understood in this larger sense, the organisms labeled "bad" because they annoy, inconvenience, or harm human beings play a necessary and positive role within the continuity of nature. In this context, they must be considered "good."

Paine's Dendroids address nature/culture contradictions in yet another way. Seen from a distance, in silhouette, their illusions of living trees are convincing. With closer proximity, however, these illusions dissolve. The soaring trunks, branching patterns, and slender twigs of the Dendroids generally observe nature's laws. Some, like *Defunct*, have jagged, truncated limbs, evidence of wounds sustained at the hand of nature. Others, like *Ferment*, have wild, dynamic sections of snarled and twisted branches, suggesting growth gone awry. But all are constructed of industrial-strength, polished, stainless steel pipes and rods of standardized diameters, laboriously cut and welded, configured, and engineered to create technological facsimiles of the real thing. They are life-less, stain-less, cold, impervious, and finished.

Yet the Dendroids are conceptually lively. They prompt us to consider the purposes to which we apply our sciences and technologies in an effort to control and manage nature. They ask us to reflect on the entirely faux environments we experience at theme parks and the faux plants that decorate homes, offices, and shopping malls. They propose a meditation on the meaning of nature for our technology- and information-obsessed world. They awaken wonder. They even may inspire a walk in the woods, travel to distant regions where nature is less impacted by culture, or encourage a new commitment to ecological concerns.

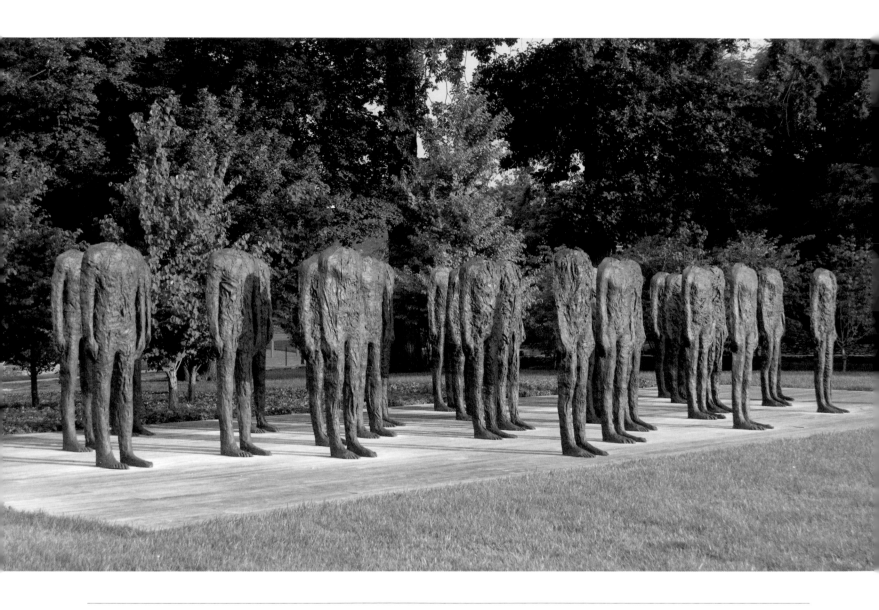

above: Magdalena Abakanowicz, *Standing Figures (Thirty Figures)*, 1994–98

right: George Segal, *Rush Hour*, 1983

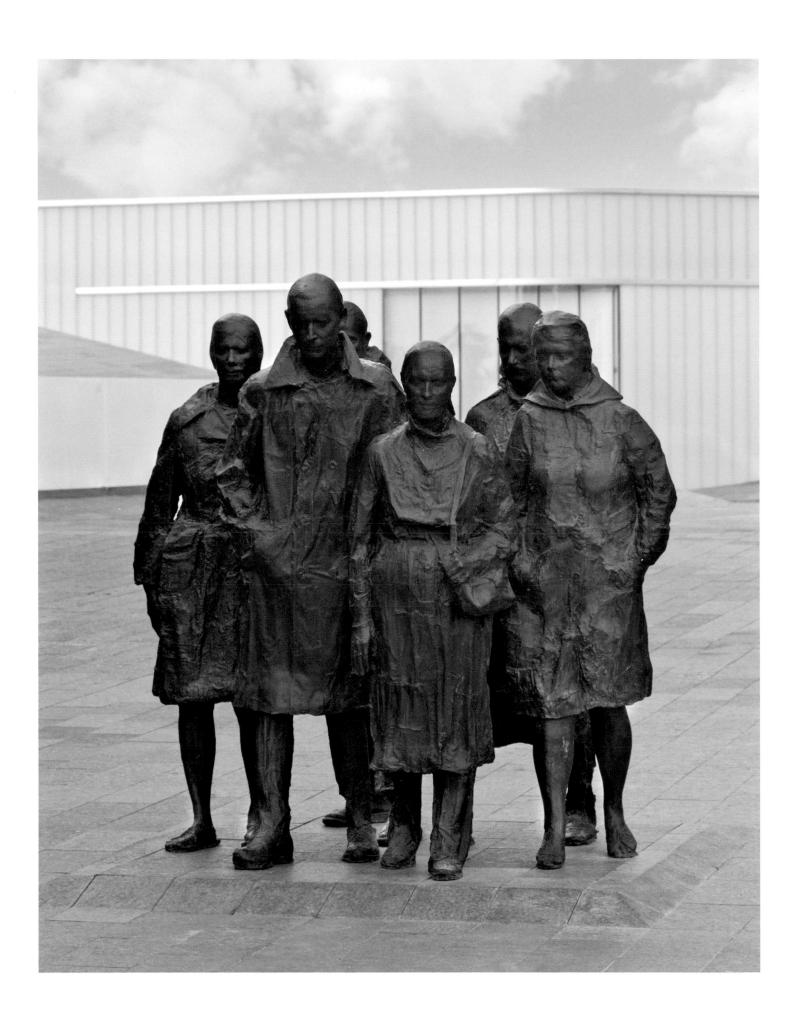

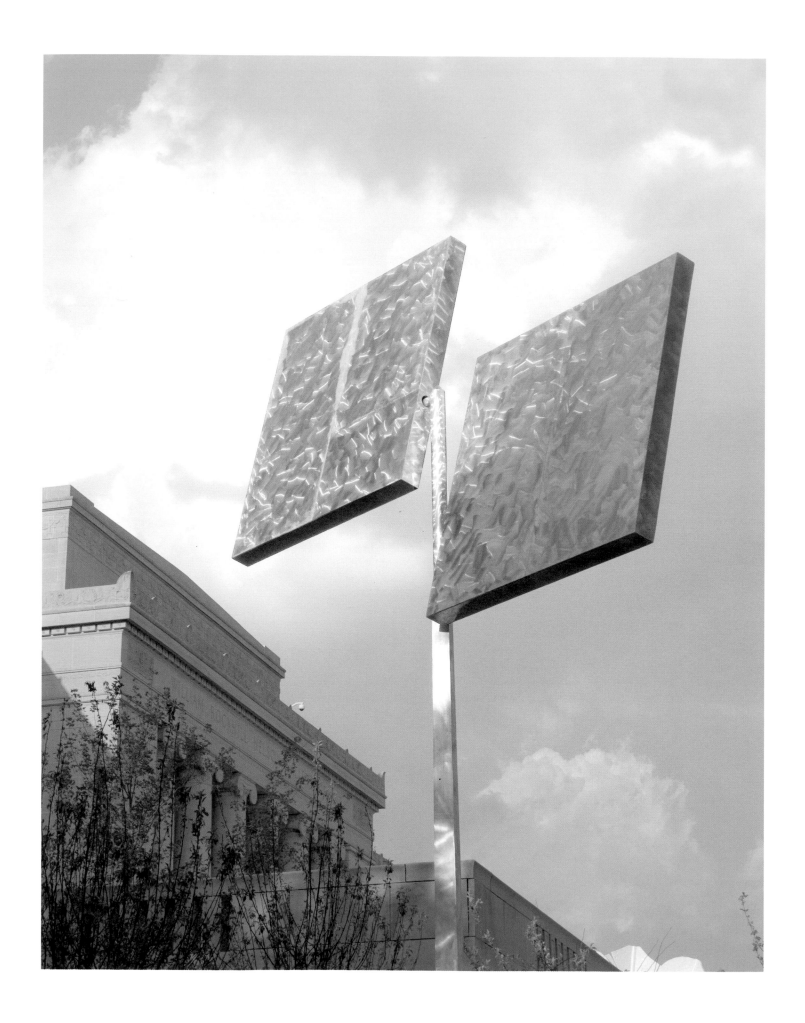

And they reveal the deep embeddedness of culture within nature and nature within culture.

Finally, the contradictions embodied in Paine's Dendroids themselves contain contradictions. *Ferment* may be lifeless, yet it cannot help but evoke archetypal meanings associated with trees. Its form implicitly aligns it with the symbolic Tree of Life that connects all of creation and with the Tree of Knowledge that symbolically unites heaven, earth, and underworld. *Ferment*, therefore, can also be read as a cosmic tree. The multivalence of its title further underscores this alignment:

1. **'Fer ment** noun; something, as a yeast, bacterium, mold or enzyme that causes fermentation.

2. **Fer 'ment** verb; to make turbulent, excite.[2]

Fermentation involves the breaking down of one thing and the creation of another in a dynamic process of transformation. That's life. Ironically, Paine's *Ferment* will not ferment. However, it came into being through a conceptual and mechanical process of breaking down, reconfiguring, and assembling amid great mental and physical turbulence to arrive, transformed, at the Nelson-Atkins. That's art.

Notes

1. "Conversation/Roxy Paine and Allan McCollum," in Susan K. Freedman and Tom Eccles, *Roxy Paine/Bluff* (New York: Public Art Fund, 2002), p. 18.

2. *Webster's II. New Riverside University Dictionary* (Boston: Houghton Mifflin, 1988), p. 472.

George Rickey, *Two Planes Vertical-Horizontal*, 1968

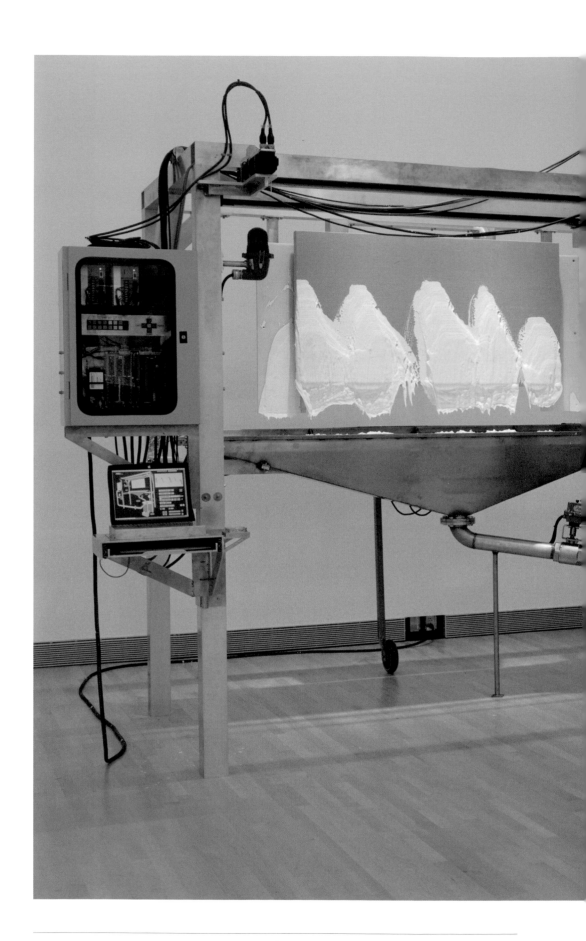

Roxy Paine, *PMU [Painting Manufacture Unit]*, 1999–2000

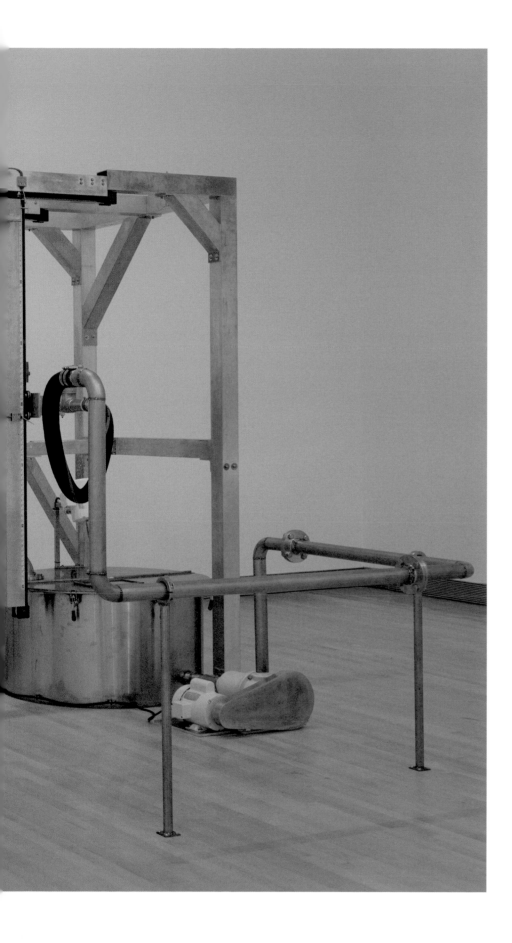

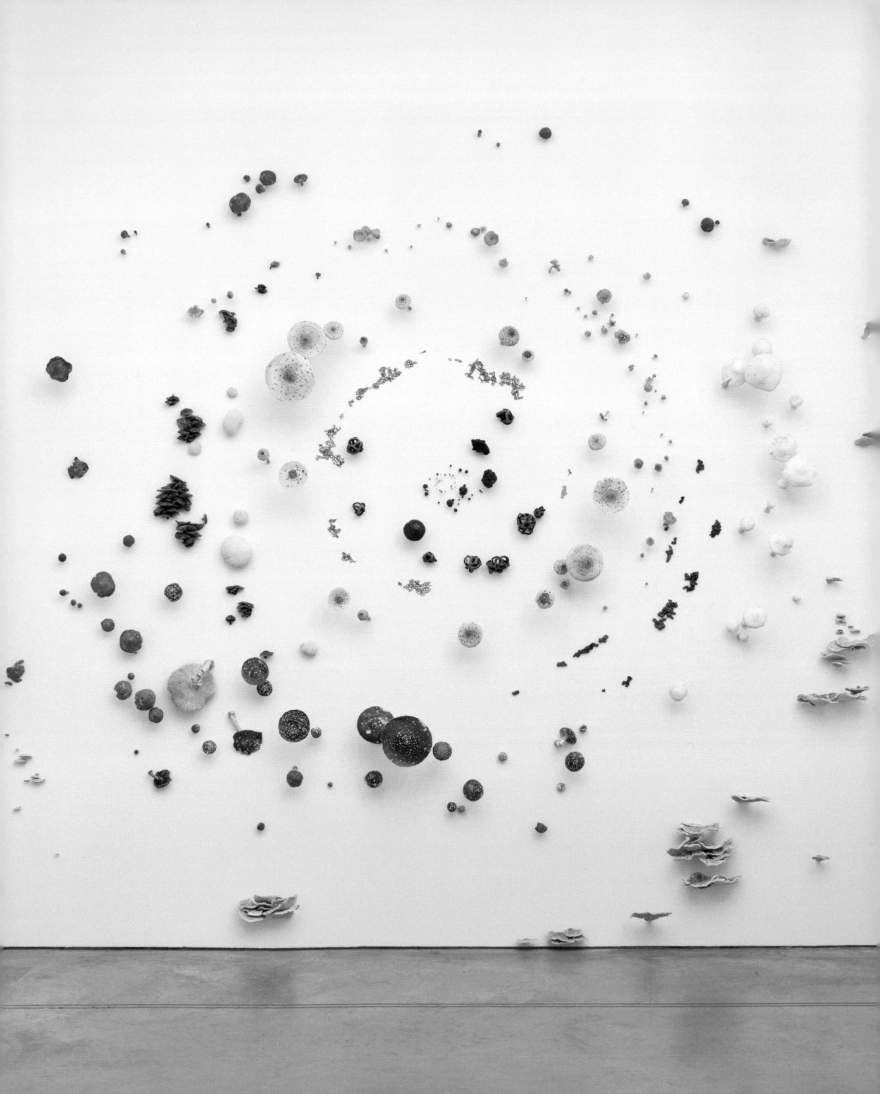

Replicants, Scumaks, and Dendroids: Notes on the Exhibition

Jan Schall

Three separate but related bodies of work make up Roxy Paine's remarkable oeuvre: the Replicants, the art-making machines, and the Dendroids. Assembled here are examples of the latter two.

I

Paine's Replicants reproduce organisms from the fungal phyla with startling veracity. From tiny to bulbous, from edible to psychotropic to deadly, from earthy brown to neon yellow and spotted red, Paine's plastic, meticulously painted fungi are presented as both scientific specimens and, in *Oscillation* (2010), as a whirling event. His fascination with fungi stems from his recognition of their necessary role in the decay of dead things, his search for edible varieties, and his earlier experimentation with psychotropic "magic mushrooms," those that alter brain activity and release visions.

Roxy Paine, *Oscillation*, 2010

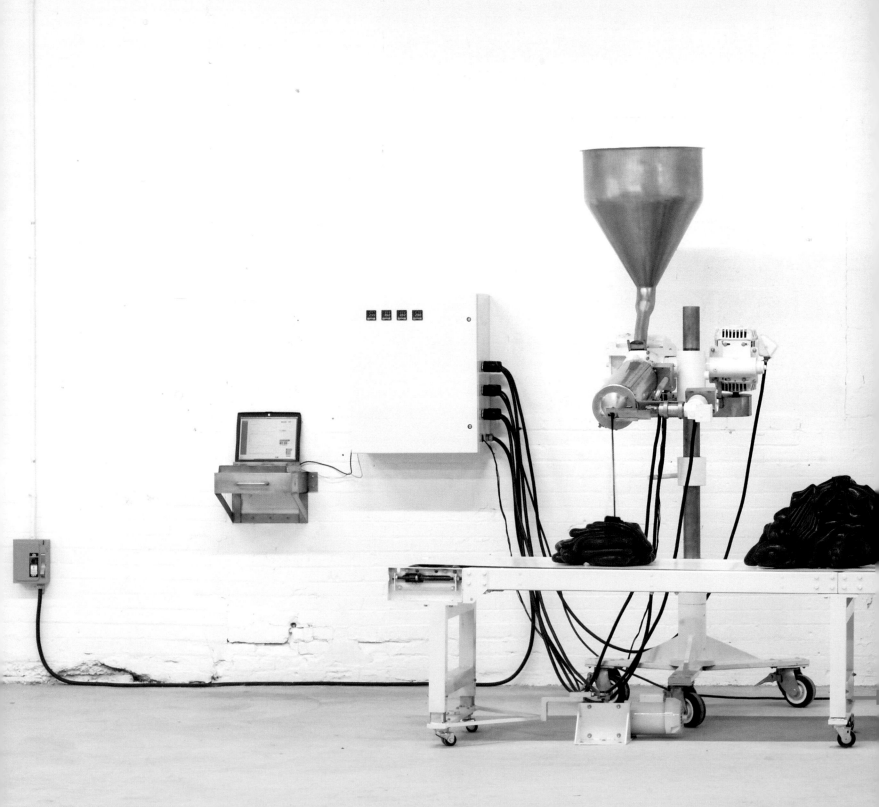

II

Computer-operated sculpture-making machines,

like *Scumak No. 2* (2001), are closely aligned with Paine's *PMUs [Painting Manufacture Units]*, and *Drawing Machines*. All address the ubiquity of automation and computerization in contemporary life. The works of art manufactured in this manner spark dialogue about the unique and the mass-produced, the mechanical and the organic, and the purpose of art and the artist. *Scumak No. 2* mimics the factory assembly line. It consists of a large stainless steel funnel into which colored polyethylene beads are loaded. Heated to the proper temperature, the beads melt, and the molten plastic is allowed to issue from the attached dispensing arm and collect on a conveyor belt. A computer program controls the size and position of the opening and the angle, direction, and duration of the pour. The plastic is allowed to cool and solidify between pours. The resultant layered sculptures are then displayed on pedestals or tables. The color of the sculptures is distinctive to each venue. With the *Scumak*s, Paine again exposes a contradiction: mechanical processes that produce organically configured sculptures. Although his hands never hold a brush or mold the forms, Paine is ultimately the maker of these works, for he has programmed the computer to act on his behalf. He considers the sculptures "portraits of the materials that each machine works with."[1]

Roxy Paine, *Scumak No. 2*, 2001

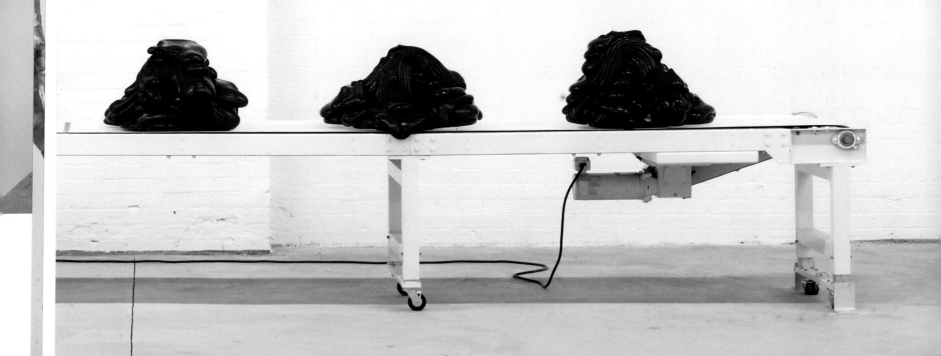

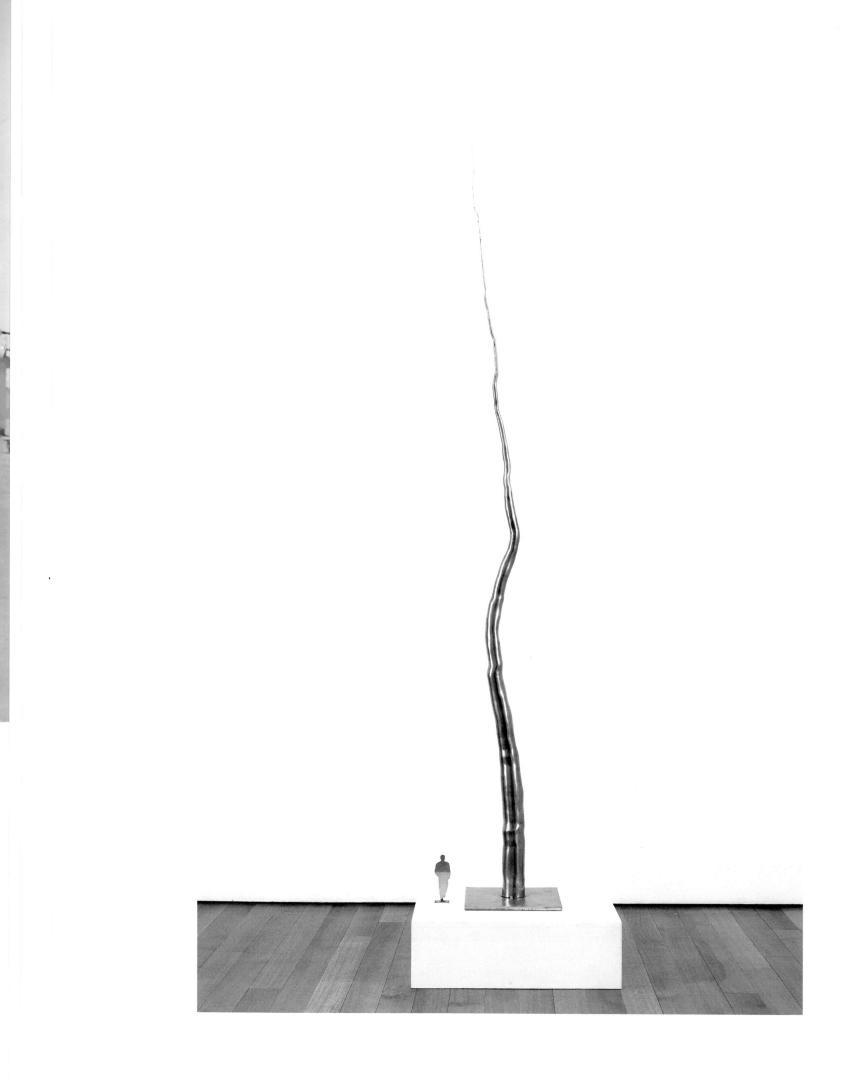

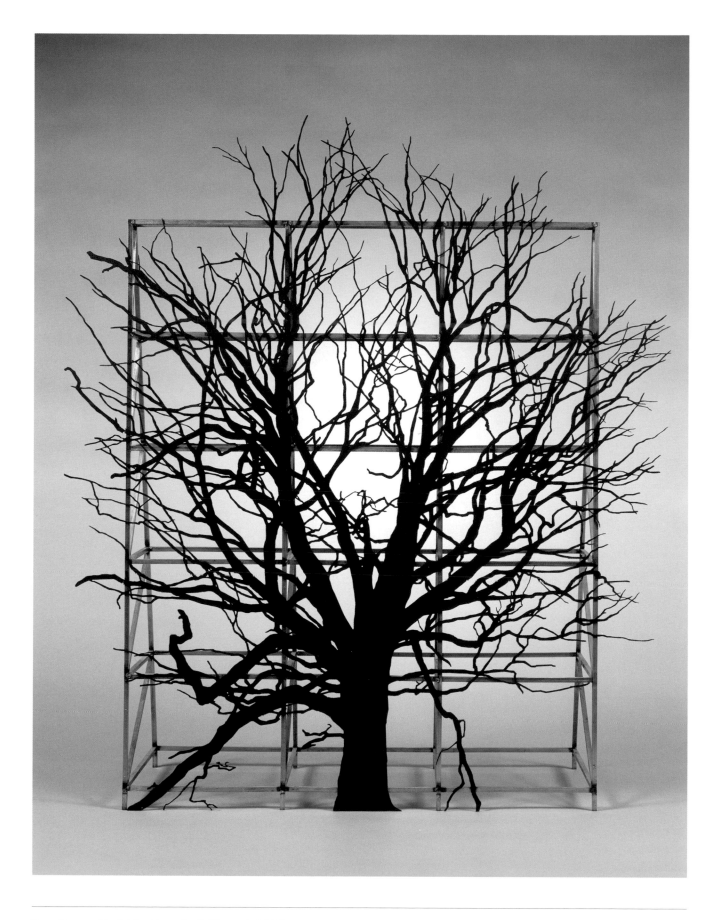

Roxy Paine, *Model for Façade/Billboard*, 2009

left: Roxy Paine, *Model for One Hundred Foot Line*, 2008

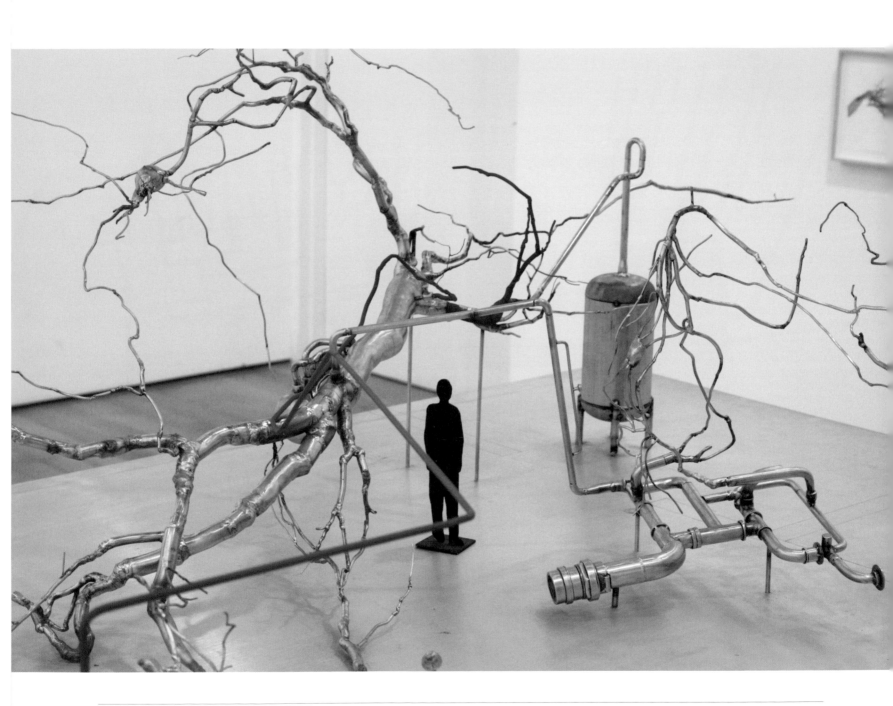

Roxy Paine, *Model for Distillation* (detail), 2010

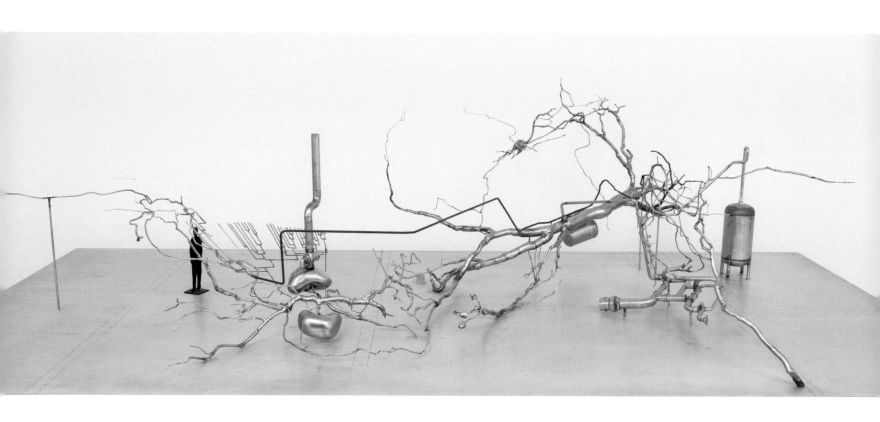

Roxy Paine, *Model for Distillation*, 2010

Ferment Fabrication

Roxy Paine Studio

Treadwell, New York

2010–2011

Roxy Paine, Ben Jones, and Sheila Griffin

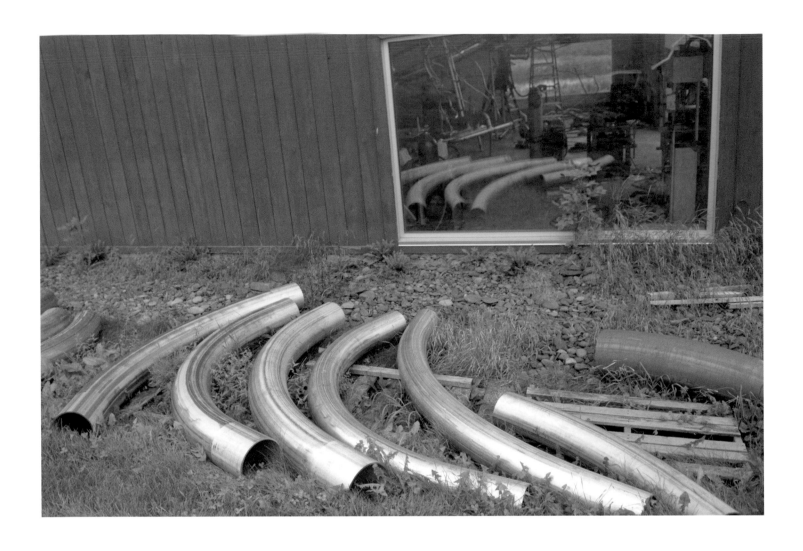

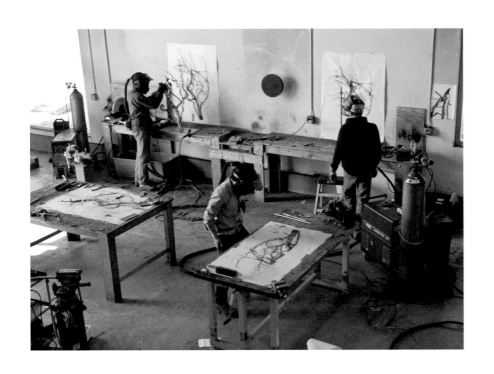

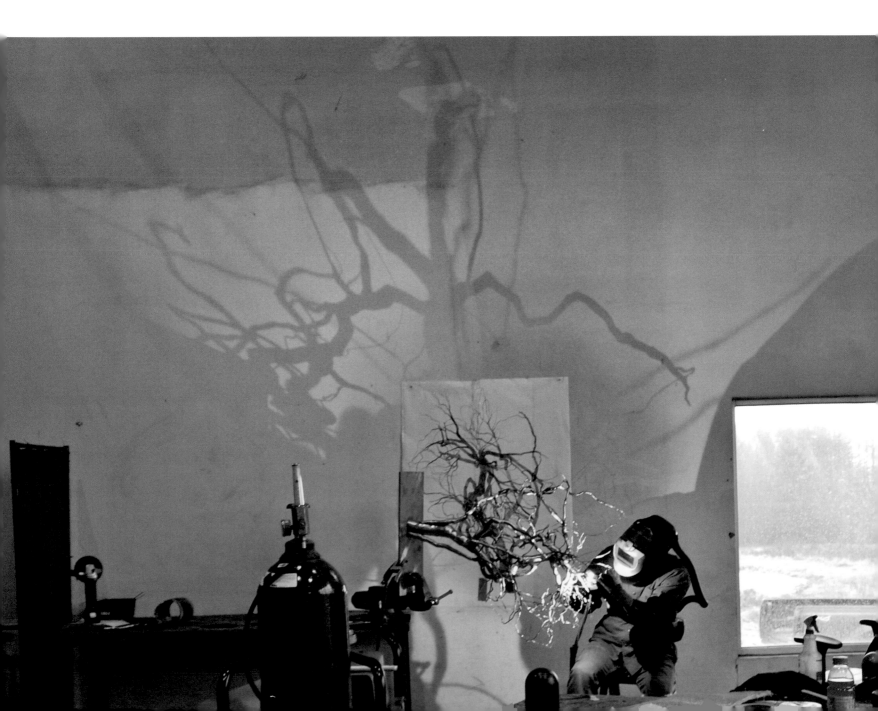

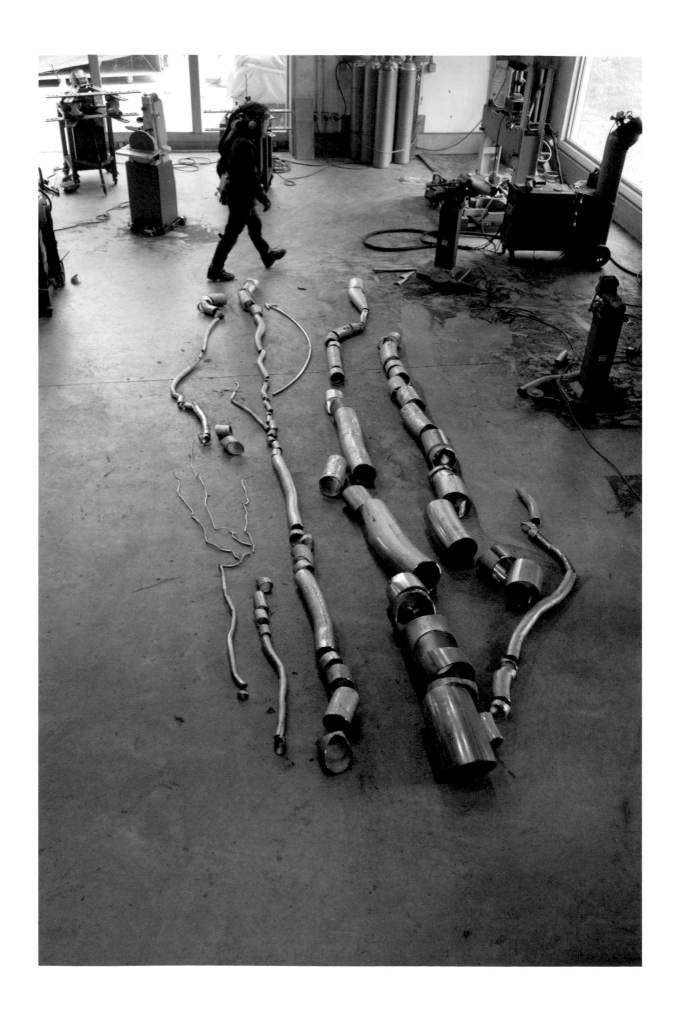

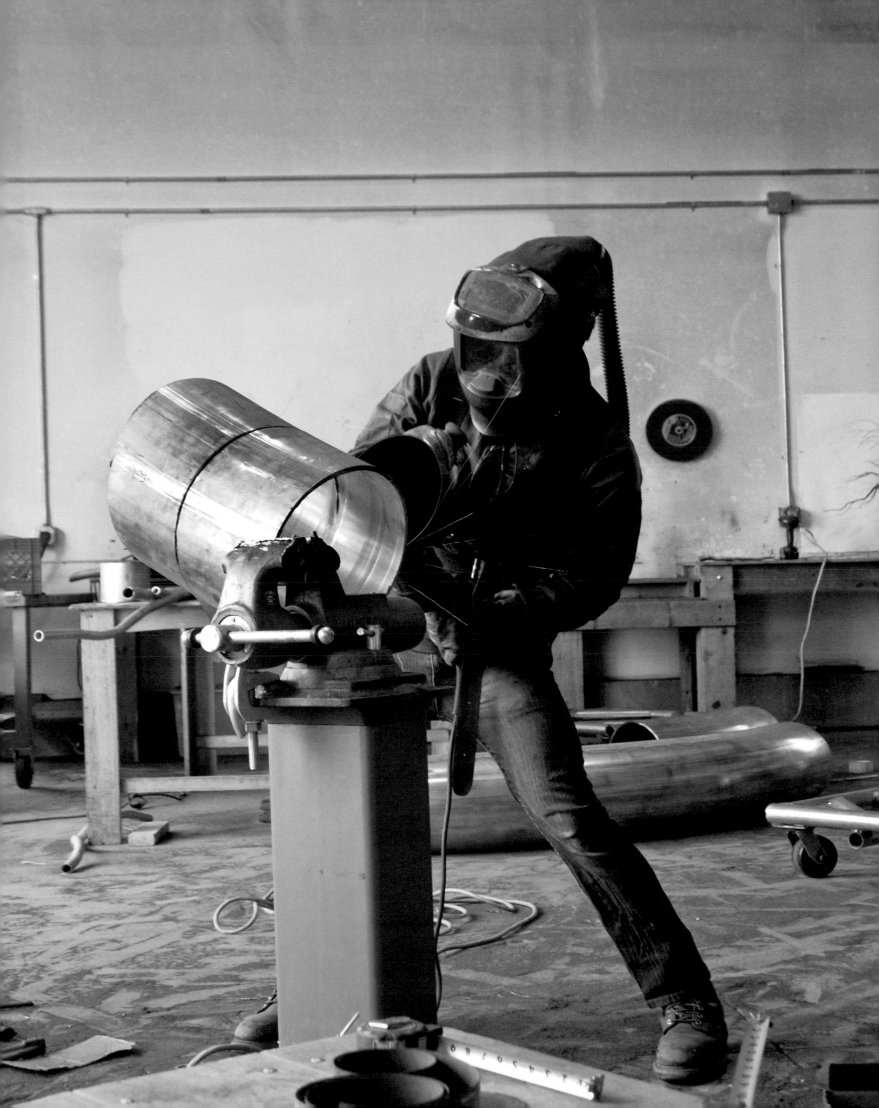

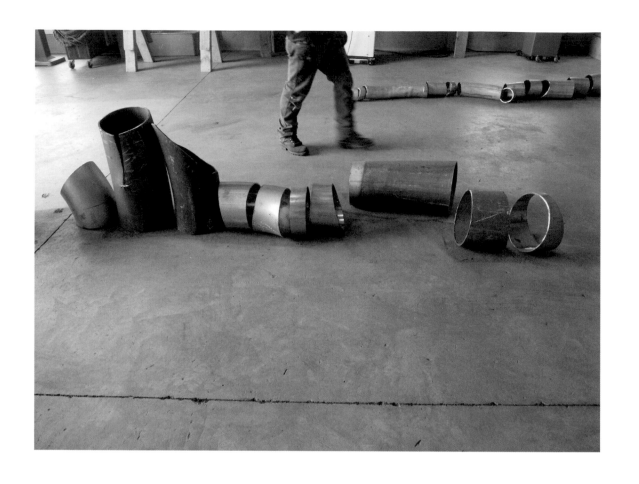

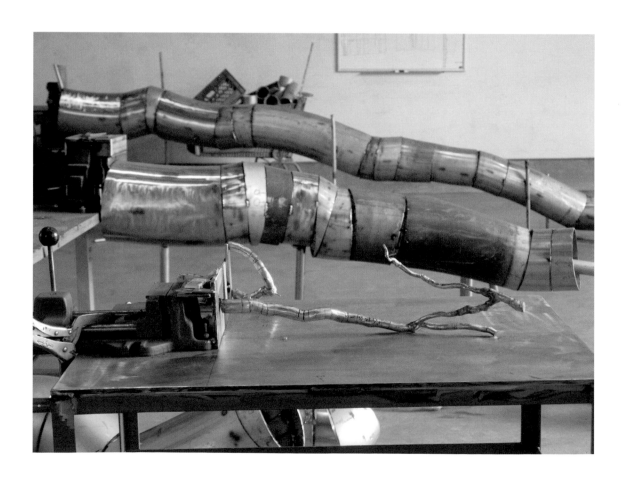

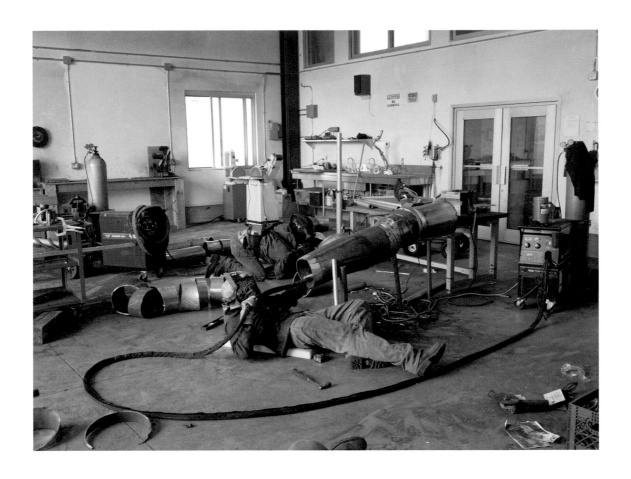

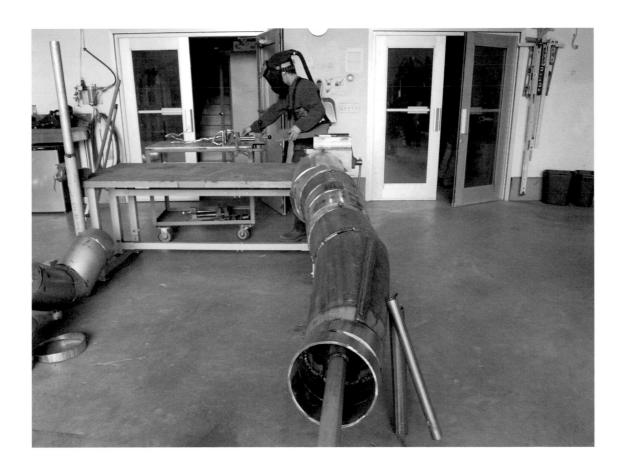

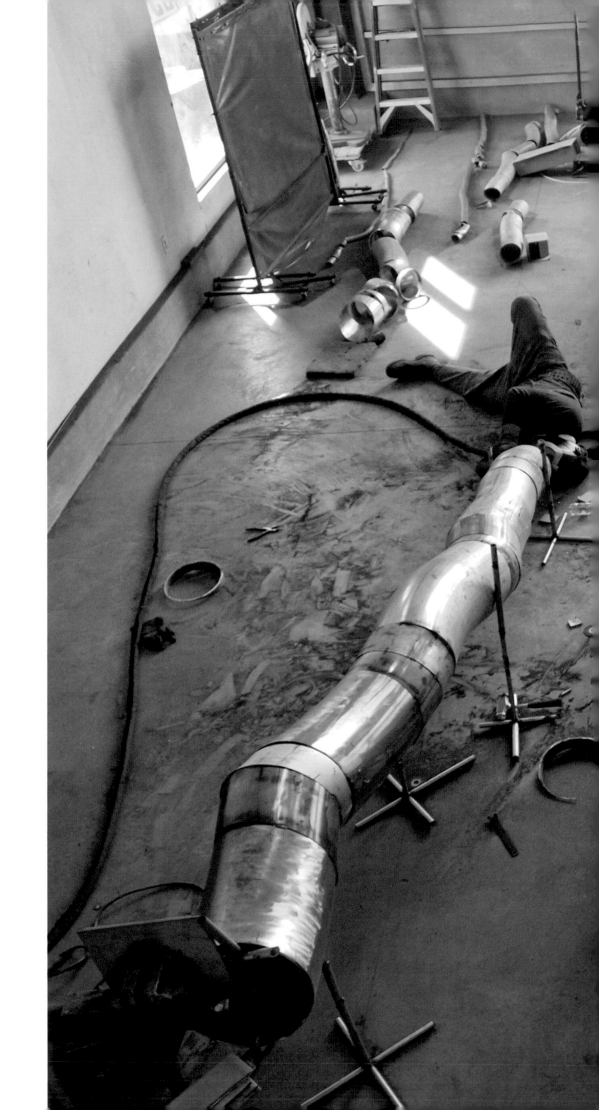

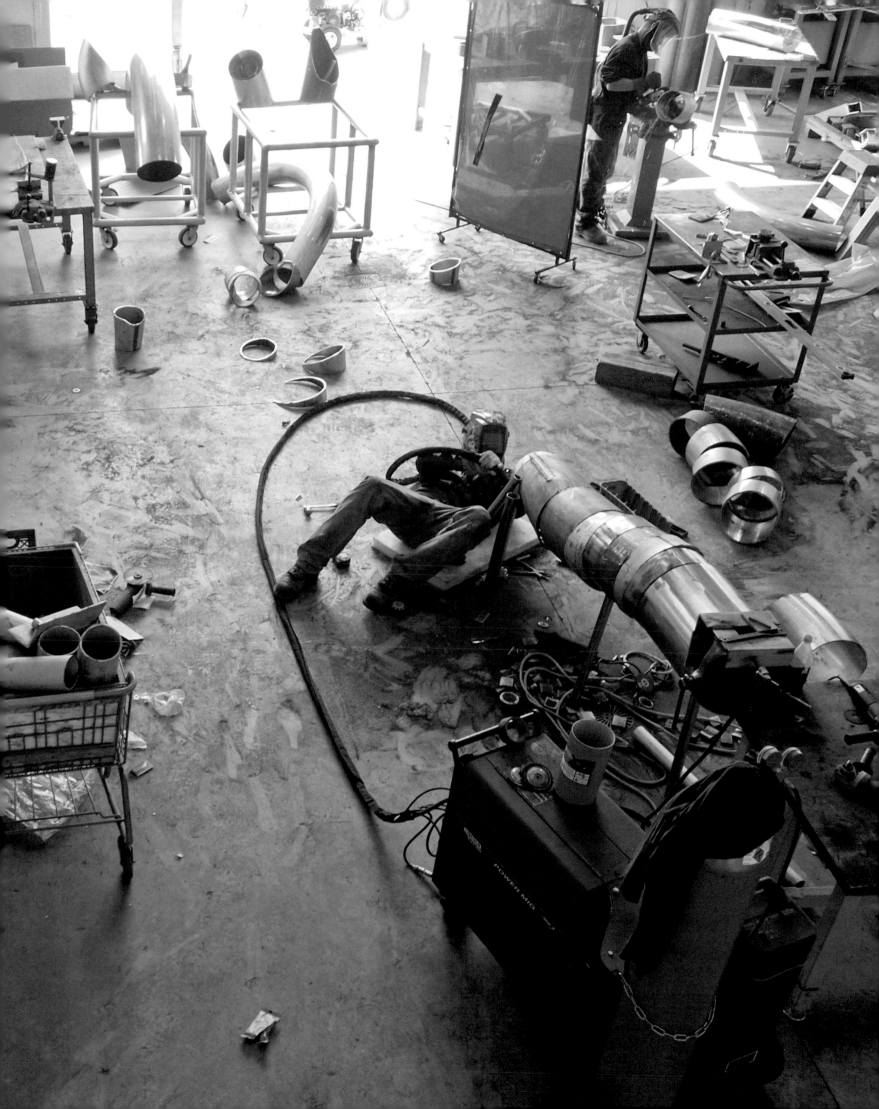

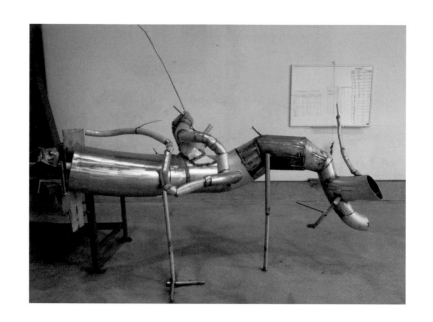

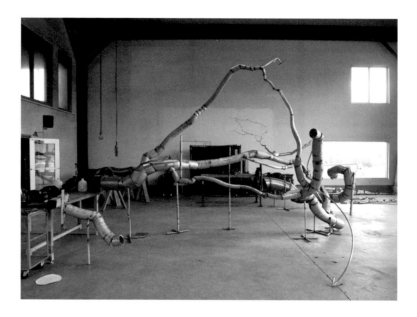

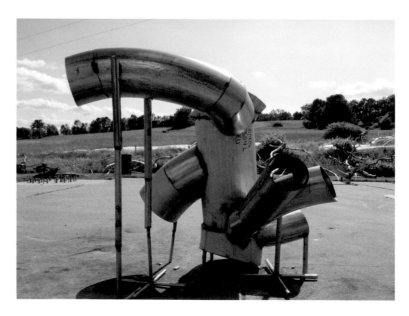

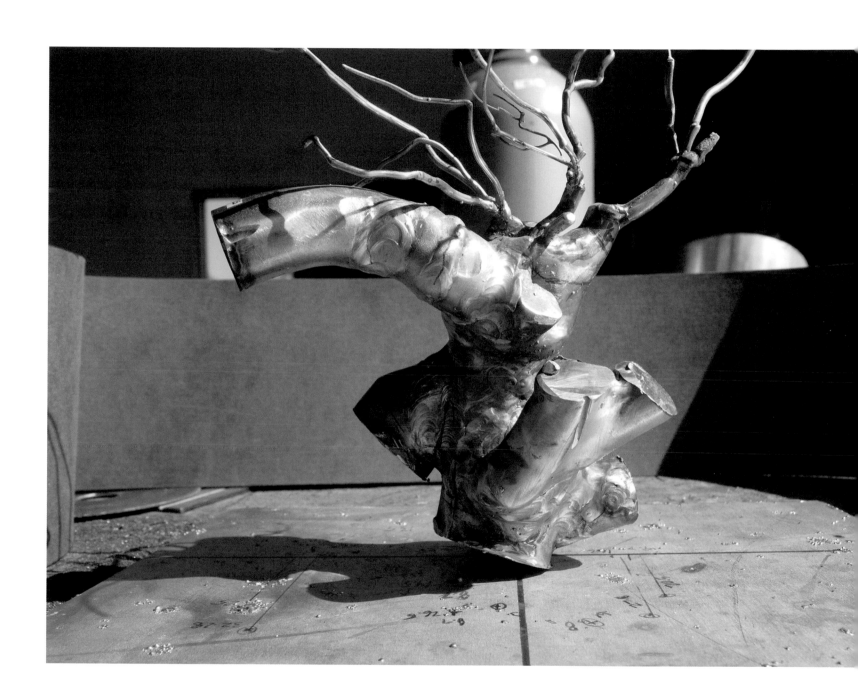

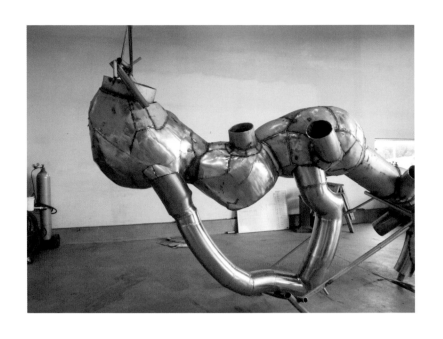

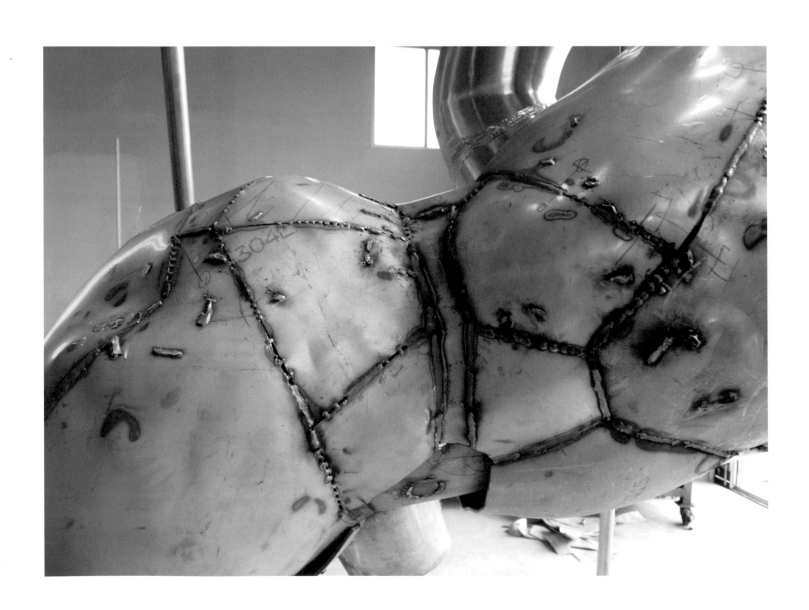

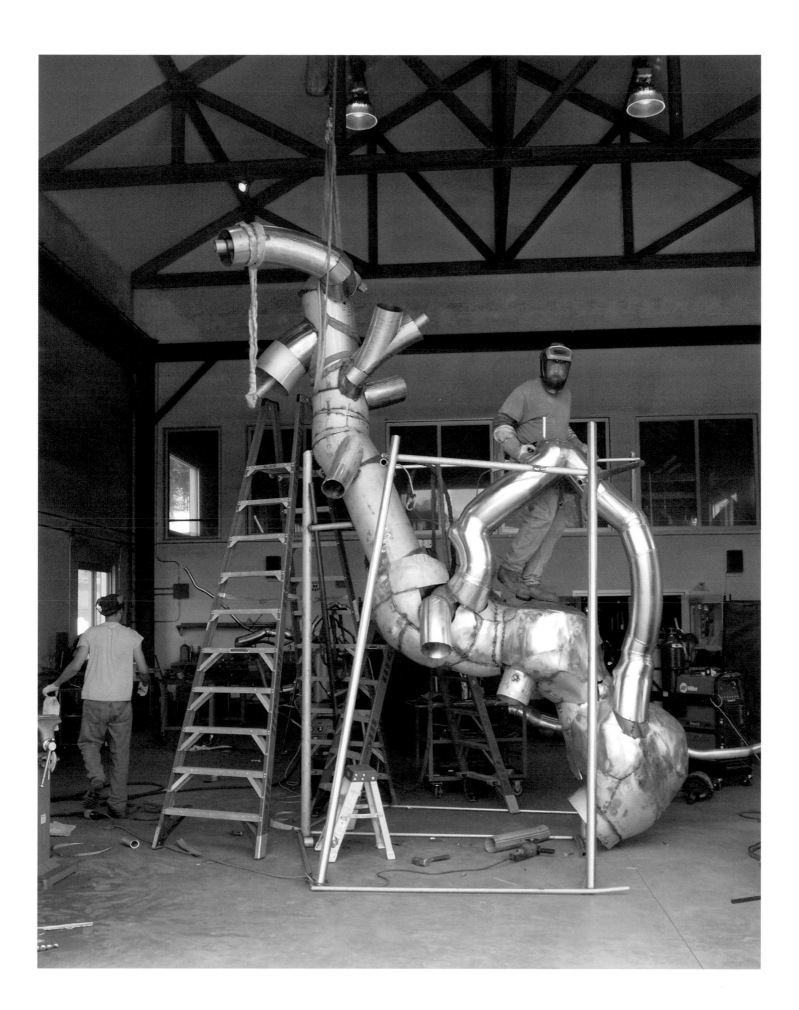

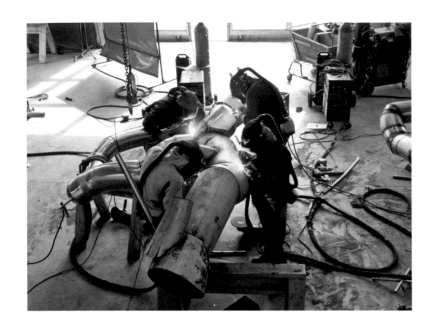

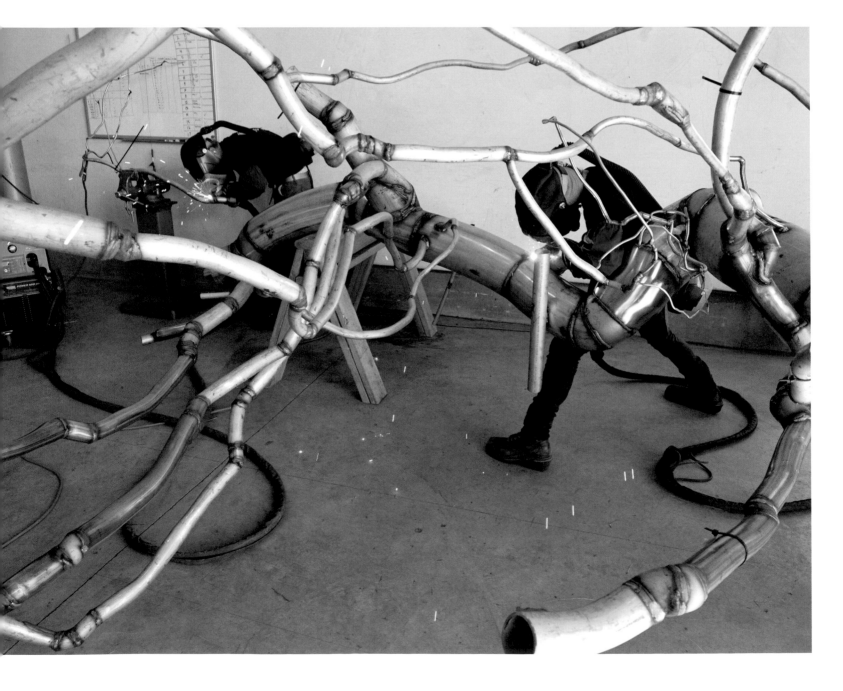

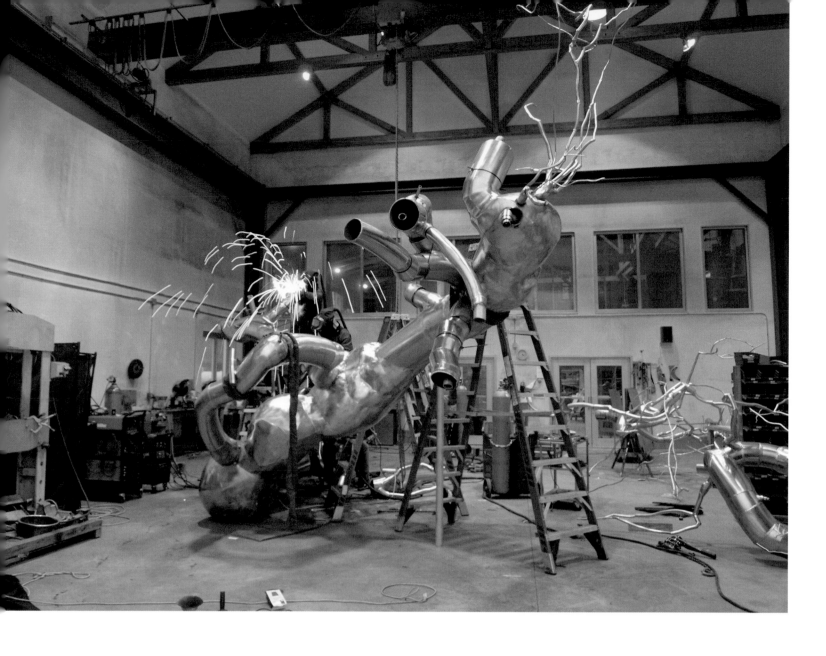

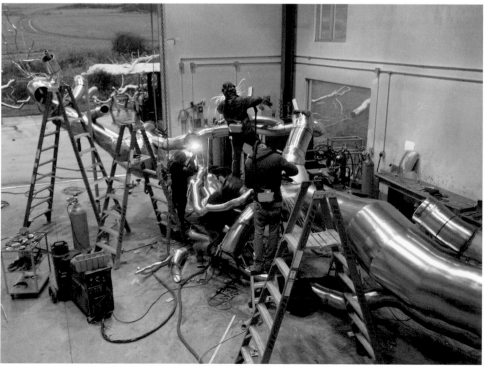

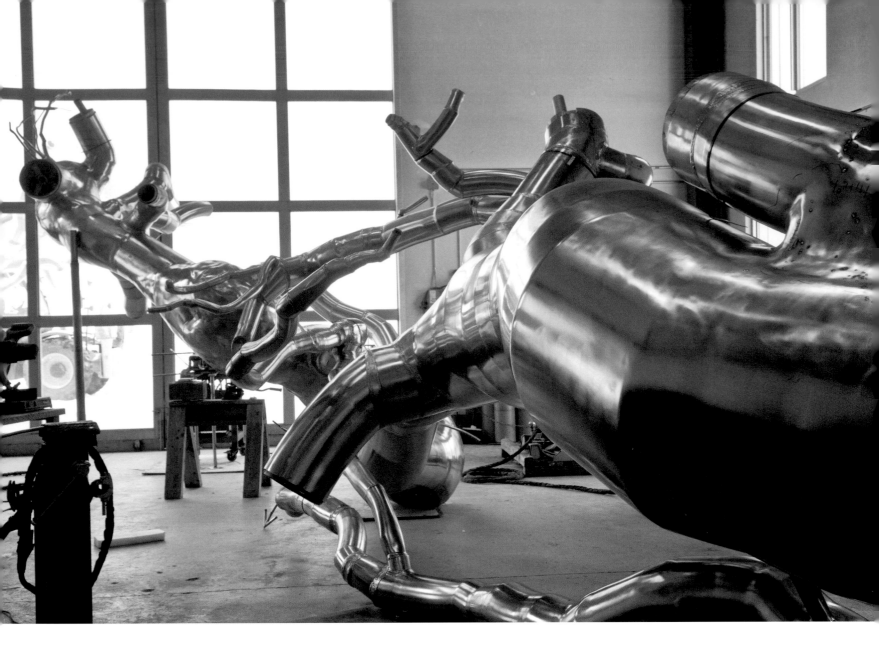

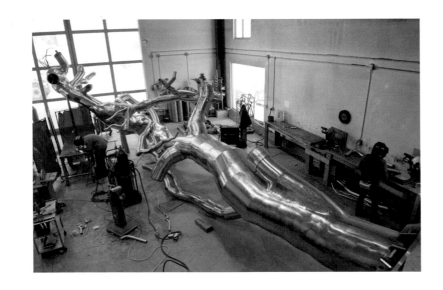

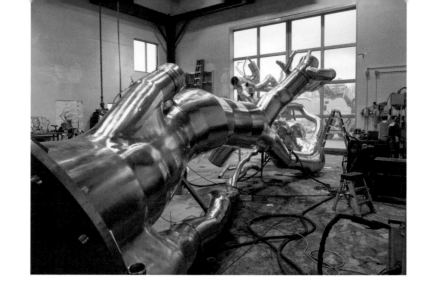

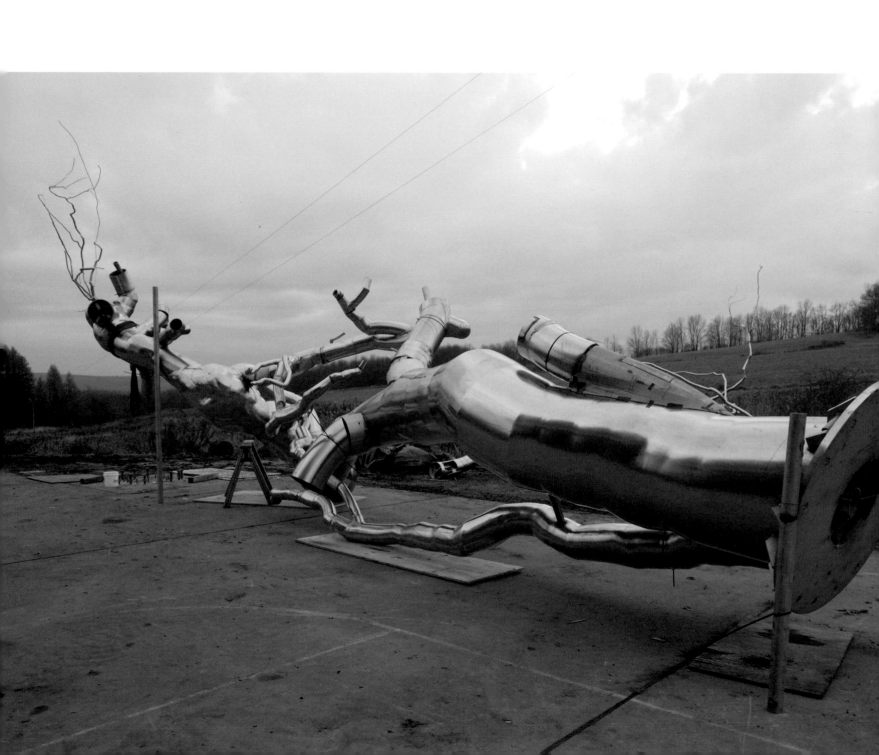

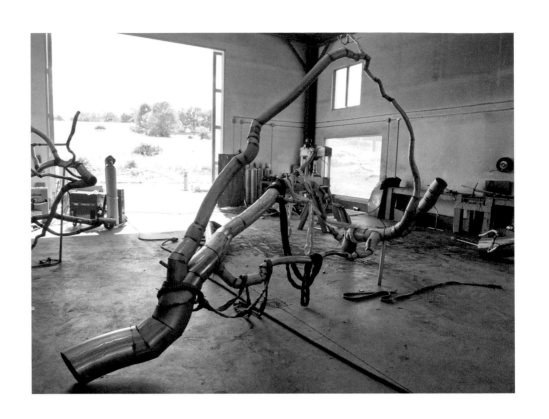

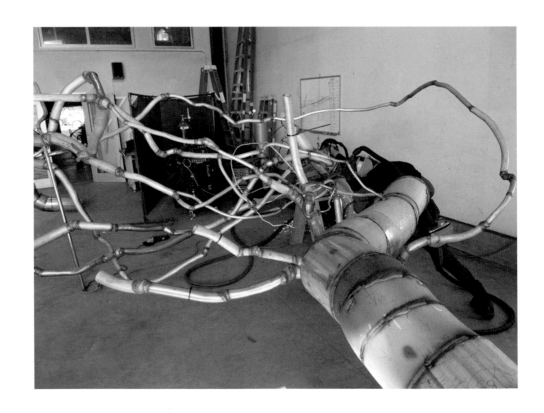

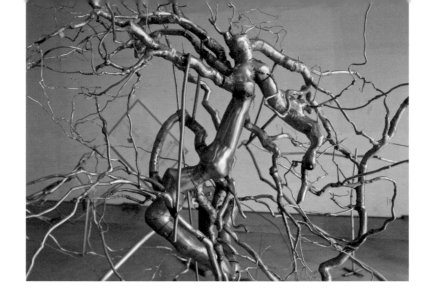

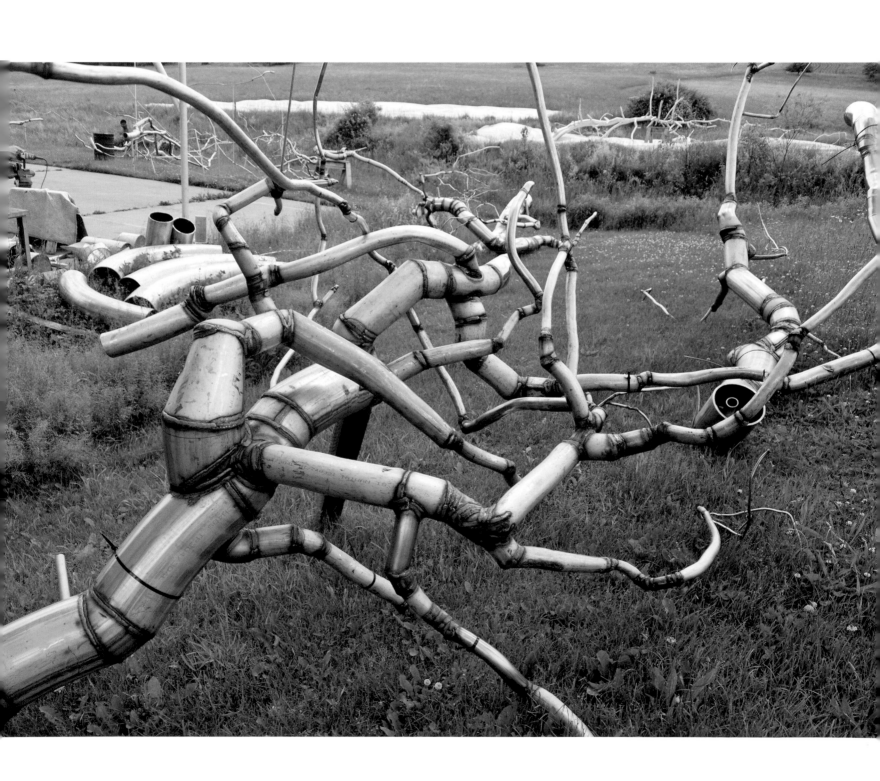

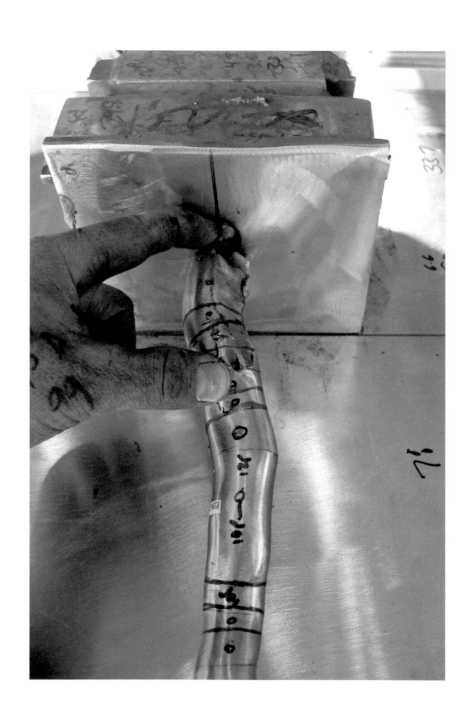

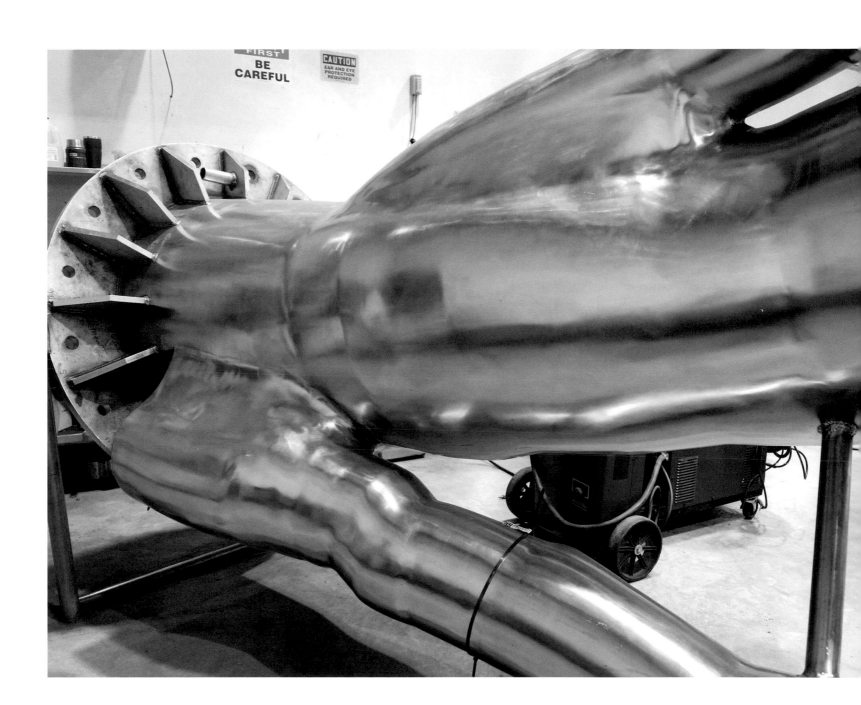

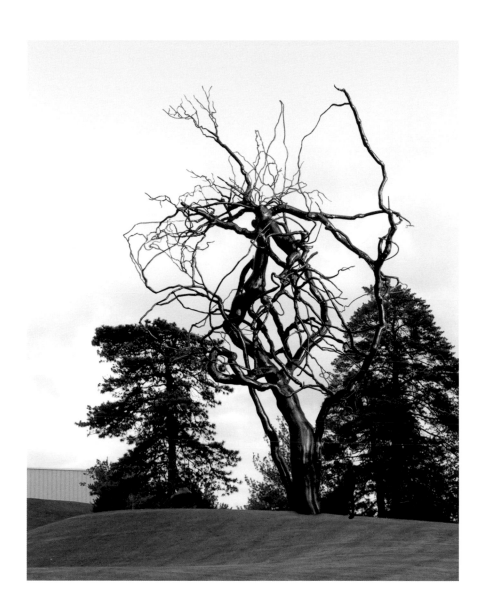

Dedicated Arbor Day, April 29, 2011

Locations of Outdoor Stainless Steel Dendroid Sculptures

Ferment, 2011

56 × 35 ft.

The Nelson-Atkins Museum of Art, Kansas City, Mo.

Discrepancy, 2011

35 ft.

Munich Re Corporate Art Collection, Munich, Germany

Tangent, 2011

28 ft.

Private collection, Greenwich, Conn.

Yield, 2011

45 × 45 ft.

Crystal Bridges Museum of American Art, Bentonville, Ark.

Containment 2, 2010

8 × 12 × 7 ft.

Private collection, Dallas

Distillation, 2010

Dimensions variable

Installed at James Cohan Gallery, New York, October 16–December 11, 2010

Façade/Billboard, 2010

47 ft.

Wanås Foundation, Knislinge, Sweden

Neuron, 2010

41 ft.

Installed at the 17th Biennale of Sydney, Museum of Contemporary Art, Sydney, Australia

One Hundred Foot Line, 2010

100 ft.

National Gallery of Canada, Ottawa, Ontario

Containment 1, 2009

14 × 8 × 8 ft.

The Broad Foundation, Los Angeles

Exhibited at Art Basel Miami Beach, December 2009

Graft, 2009

45 ft.

National Gallery Sculpture Garden, Washington, D.C.

Maelstrom, 2009

22 × 140 ft.

Temporary installation at the Metropolitan Museum of Art, New York,

Iris B. and Gerald Cantor Roof Garden, April 28–November 29, 2009

Inversion, 2008

42 × 35 ft.

The Israel Museum, Jerusalem, installed January 2011

Temporarily exhibited at Den Haag Sculptuur 2008, June–August 2008; created

for the Public Art Projects for Art Basel 39, Basel, Switzerland, June 4–8, 2008

Askew, 2008

43 ft.

North Carolina Museum of Art, Raleigh

Conjoined, 2007

40 × 45 ft.

Modern Art Museum of Fort Worth, Tex.

Exhibited at Madison Square Park, New York, May 2007–February 2008

Fallen Tree, 2006
20 ft.
Private collection, Millbrook, N.Y.

Olive, 2006
20 ft.
Private collection, New York

Misnomer, 2005
12 ft.
Private collection, East Hampton, N.Y.

Defunct, 2004
50 ft.
Private collection, Switzerland
Exhibited at Madison Square Park, New York, May 2007–February 2008

Placebo, 2004
50 ft.
Saint Louis Art Museum, St. Louis, Mo.

Palimpsest, 2004
26 ft.
Private collection, Los Angeles

Breach, 2003
35 ft.
Sheldon Memorial Art Gallery, University of Nebraska, Lincoln

Interim, 2003
35 ft.
Private collection, promised gift to the Toledo Museum of Art, Ohio

Substitute, 2003
37 ft.
Private collection, Milwaukee, Wisc.

Split, 2003

50 ft.

Olympic Sculpture Park, Seattle Art Museum

Bluff, 2002

50 ft.

Private collection, Ossining, N.Y.

Commissioned by the Public Art Fund and the Whitney Biennial 2002,

installed temporarily in Central Park, New York

Transplant, 2001

46 ft.

NMAC, Cadiz, Spain

Impostor, 1999

27 ft.

Wanås Foundation, Knislinge, Sweden

Biography and Exhibitions

Born in New York, New York, 1966. Studied at Pratt Institute, New York, and the College of Santa Fe, New Mexico. Received John Simon Guggenheim Memorial Foundation Fellowship, 2006, and Trustees Award for an Emerging Artist, Aldrich Museum of Contemporary Art, Ridgefield, Connecticut, 1997.

Selected Solo Exhibitions

Roxy Paine: Distillation. James Cohan Gallery, New York, October 16–December 11, 2010.

Wanås Foundation, Knislinge, Sweden, May 31–October 31, 2010.

Roxy Paine: Machinations. James Cohan Gallery, Shanghai, China, April 24–June 13, 2010.

Roxy Paine: Dendroid Drawings and Maquettes. James Cohan Gallery, New York, May–June 6, 2009.

Roxy Paine on the Roof: Maelstrom. The Metropolitan Museum of Art, New York, April 28–November 29, 2009.

Roxy Paine: SCUMAKS. James Cohan Gallery, New York, June 26–August 1, 2008.

Roxy Paine: Three Sculptures. Commissioned by Madison Square Park Conservancy, Madison Square Park, New York, May 15, 2007–February 28, 2008.

Roxy Paine: PMU. Curated by Bruce Guenther, Portland Museum of Art, Portland, Oreg., February 25–May 28, 2006.

Roxy Paine: New Work. James Cohan Gallery, New York, January 14–February 25, 2006.

Defunct. Aspen Art Museum, Aspen, Colo., July 23, 2004–November 20, 2006.

Roxy Paine: Inoculate. James Cohan Gallery, New York, November 8–December 22, 2002.

Roxy Paine: Second Nature. Curated by Joseph Ketner and Lynn Herbert, Rose Art Museum, Brandeis University, Waltham, Mass., April 25–July 14, 2002. Traveled to Contemporary Arts Museum, Houston, Tex., October 19, 2002–January 12, 2003; SITE Santa Fe, N.Mex., April 26–July 6, 2003; De Pont Museum for Contemporary Art, Tilburg, The Netherlands, September 20, 2003–January 11, 2004.

Scumaks. Bernard Toale Gallery, Boston, April 24–May 25, 2002.

* Accompanied by an exhibition catalogue

PMU [Painting Manufacture Unit]. Museum of Contemporary Art, North Miami, Fla., November 11, 2001–January 27, 2002.

Grand Arts, Kansas City, Mo., June 29–August 11, 2001.

Christopher Grimes Gallery, Los Angeles, May 26–June 30, 2001.

Roxy Paine: New Work. James Cohan Gallery, New York, April 5–May 5, 2001.

Roxy Paine: Amanita Fields. Galerie Thomas Schulte, Berlin, Germany, February 13–April 20, 2001.

Roger Bjorkholmen Gallery, Stockholm, Sweden, February 26–March 31, 1999.

Ronald Feldman Fine Arts, New York, January 9–February 13, 1999.

Musée d'Art Américain Giverny, Giverny, France, June 1–November 15, 1998. Traveled to Lunds Kunsthall, Lund, Sweden, March 6–April 18, 1999.

Renate Schroder Galerie, Cologne, Germany, April 24–June 6, 1998.

Temple Gallery, Tyler School of Art, Temple University, Philadelphia, September 5–October 11, 1997.

Ronald Feldman Fine Arts, New York, March 15–April 26, 1997.

Ronald Feldman Fine Arts, New York, April 29–June 3, 1995.

Herron Test-Site, Brooklyn, N.Y., October 9–November 8, 1992.

Horns. Knitting Factory, New York, December 3–31, 1991.

Selected Group Exhibitions

2010

The Secret Life of Trees. Monica de Cardenas Galleria, Zuoz, Switzerland, July 24–September 5, 2010.

17th Biennale of Sydney: The Beauty of Distance; Songs of Survival in a Precarious Age, Sydney, Australia, May 12–August 1, 2010.

Out of the Woods. Leslie Tonkonow, New York, January 30–March 6, 2010.

2009

The Rose at Brandeis: Works from the Collection. Rose Art Museum, Brandeis University, Waltham, Mass., October 29, 2009–June 20, 2010.

Remote Proximity: Nature in Contemporary Art. Kunstmuseum Bonn, Germany, September 10–November 15, 2009.

Reflection, Refraction, Reconfiguration: Mediated Images from the Collection of Polly and Mark Addison. University Art Museum, Colorado State University, Fort Collins, March 28–June 13, 2009.

2008

Bizarre Perfection. Israel Museum, Jerusalem, December 20, 2008–June 6, 2009.

Bending Nature. Franklin Park Conservatory, Columbus, Ohio, October 4, 2008–
March 29, 2009.

Freedom. Den Haag Sculptur 2008, The Hague, The Netherlands, June 15–August 31,
2008.

Public Art Projects. Art Basel 39, Basel, Switzerland, June 3–9, 2008.

Paragons: New Abstraction from the Albright-Knox Gallery. Doris McCarthy Gallery,
University of Toronto-Scarborough, Ontario, Canada, January 17–March 9, 2008.

2007

Delicatessen. Dorothy F. Schmidt Center Gallery, Florida Atlantic University, Boca Raton,
November 9, 2007–January 26, 2008.

**Art Machines/Machine Art*. Schirn Kunsthalle, Frankfurt, Germany, October 18, 2007–
January 27, 2008. Traveled to Museum Tinguely, Basel, Switzerland, March 5–June 29,
2008.

The Outdoor Gallery: 40 Years of Public Art in New York City Parks. Arsenal Gallery in
Central Park, New York, September 25–November 23, 2007.

Drawings from the Collection of Martina Yamin. Davis Museum and Cultural Center,
Wellesley College, Wellesley, Mass., September 19–December 9, 2007.

**Molecules That Matter*. Tang Teaching Museum, Skidmore College, Saratoga Springs,
N.Y., September 8, 2007–April 13, 2008. Traveled to Chemical Heritage Foundation,
Philadelphia, August 18, 2008–January 9, 2009; College of Wooster Art Museum,
Wooster, Ohio, March 24–May 10, 2009; Mayborn Museum Complex, Baylor
University, Waco, Tex., June–August 2009; and Faulconer Gallery, Bucksbaum Center
for Arts, Grinnell College, Grinnell, Iowa, September–December 2009.

2006

Meditations in an Emergency. Museum of Contemporary Art, Detroit, October 28,
2006–April 29, 2007.

Recent Acquisitions. Musée d'Art Contemporain de Montréal, October 28, 2006–
March 25, 2007.

A Brighter Day. James Cohan Gallery, New York, June 9–July 14, 2006.

Garden Paradise. Curated by Lacy Davisson Doyle and Clare Weiss, Arsenal Gallery in
Central Park, New York, April 20–May 24, 2006.

American Academy Invitational Exhibition of Painting & Sculpture. American Academy of
Arts and Letters, New York, March 7–April 9, 2006.

Uneasy Nature. Curated by Xandra Eden, Weatherspoon Art Museum, University of North
 Carolina, Greensboro, February 18–May 28, 2006.

2005

**Ecstasy: In and about Altered States*. Organized by Paul Schimmel with Gloria Sutton,
 Museum of Contemporary Art, Los Angeles, October 9, 2005–February 20, 2006.
The Empire of Sighs. Numark Gallery, Washington, D.C., September 16–October 29,
 2005.
Extreme Abstraction. Albright-Knox Art Gallery, Buffalo, N.Y., July 15–October 2, 2005.
Sculpture. James Cohan Gallery, New York, May 7–June 25, 2005.
Flower Myth: Vincent van Gogh to Jeff Koons. Fondation Beyeler, Riehen/Basel, Switzerland,
 February 27–May 22, 2005.
**MATERIAL TERRAIN: A Sculptural Exploration of Landscape and Place*. Curated by Carla
 Hanzal, commissioned by Laumeier Sculpture Park, St. Louis, Mo., February 11–
 May 15, 2005. Traveled to Santa Cruz Museum of Art and History, Santa Cruz, Calif.,
 July 2–September 25, 2005; University of Arizona Museum of Art, Tucson, January 13–
 April 2, 2006; Memphis Brooks Museum of Art, Memphis, Tenn., September 16–
 November 26, 2006; Cheekwood Museum of Art, Nashville, Tenn., March 17–June 17,
 2007; Columbia Museum of Art, Columbia, S.C., July 6–August 26, 2007; Lowe Art
 Museum, University of Miami, Coral Gables, Fla., September 15–November 27, 2007.

2004

PILLish: Harsh Realities and Gorgeous Destinations. Curated by Cydney Payton, Museum of
 Contemporary Art, Denver, October 1, 2004–January 2, 2005.
The Flower as Image. Louisiana Museum for Moderne Kunst, Humlebæk, Denmark,
 September 10, 2004–January 16, 2005.
Paintings That Paint Themselves, or So It Seems. Kresge Art Museum, Michigan State
 University, East Lansing, September 7–October 31, 2004.
The Summer Show. James Cohan Gallery, New York, July 9–August 20, 2004.
Natural Histories: Realism Revisited. Scottsdale Museum of Contemporary Art, Scottsdale,
 Ariz., May 29–September 12, 2004.
Between the Lines. James Cohan Gallery, New York, May 7–June 12, 2004.

2003

Work Ethic. Baltimore Museum of Art, October 12, 2003–January 11, 2004. Traveled to
 Des Moines Center for the Arts, Iowa, May 15–August 1, 2004.

The Great Drawing Show, 1550–2003 AD. Michael Kohn Gallery, Los Angeles, April 12–
May 31, 2003.

Decade. Schroeder Romero, Brooklyn, N.Y., April 11–May 19, 2003.

**UnNaturally.* Organized by Independent Curators International, curated by Mary-Kay
Lombino, Contemporary Art Museum, University of South Florida, Tampa, January 13–
March 8, 2003. Traveled to H & R Block Artspace at the Kansas City Art Institute, Kansas
City, Mo., September 19–October 29, 2003; Fisher Gallery, University of Southern
California, Los Angeles, November 19, 2003–January 17, 2004; Copia: The American
Center for Wine, Food and the Arts, Napa, Calif., April 30–August 16, 2004; Lowe Art
Museum, University of Miami, Coral Gables, Fla., September 14–November 14, 2004.

2002

Early Acclaim: Emerging Artist Award Recipients, 1997–2001. Aldrich Museum of
Contemporary Art, Ridgefield, Conn., September 22–December 31, 2002.

Painting Matter. James Cohan Gallery, New York, May 3–June 15, 2002.

The Whitney Biennial. Curated by Tom Eccles, organized by the Public Art Fund, New York,
in collaboration with the Whitney Museum of American Art, Central Park, New York,
March 7–May 30, 2002.

2001

Brooklyn! Palm Beach Institute of Contemporary Art, Lake Worth, Fla., September 4–
November 25, 2001.

**Arte y naturaleza.* Montenmedio Arte Contemporaneo (NMAC), outdoor sculpture garden,
Cadiz, Spain, June 2–October 2, 2001.

Present Tense 6. Israel Museum, Jerusalem, May–December 2001.

**Waterworks: U.S. Akvarell 2001.* Curated by Kim Levin, Nordiska Akvarellmuseet,
Skarhamn, Sweden, May 19–September 2, 2001.

**01.01.01: Art in Technological Times.* San Francisco Museum of Modern Art, March 3–
July 8, 2001.

All-Terrain. Contemporary Art Center of Virginia, Virginia Beach, February 22–April 29,
2001.

Give and Take. Serpentine Gallery in collaboration with the Victoria and Albert Museum,
London, January 30–April 1, 2001.

A Contemporary Cabinet of Curiosities: Selections from the Vicki and Kent Logan Collection.
California College of Arts and Crafts, San Francisco, January 17–March 3, 2001.

Making the Makin. Apex Art, New York, January 5–February 3, 2001.

2000

From a Distance: Approaching Landscape. Curated by Jessica Morgan, Institute of Contemporary Art, Boston, July 19–October 8, 2000.

WILDflowers. Katonah Museum of Art, Katonah, N.Y., July 18–October 3, 2000.

Working in Brooklyn: Beyond Technology. Brooklyn Museum of Art, Brooklyn, N.Y., July 1–September 12, 2000.

5th Lyon Biennale of Contemporary Art: Sharing Exoticism. Lyon, France, June 27– September 24, 2000.

Vision Ruhr. Dortmund Coal Factory, Dortmund, Germany, May 11–August 20, 2000.

The Greenhouse Effect. Serpentine Gallery, London, April 4–May 21, 2000.

Sites around the City: Art and Environment. Curated by Heather Sealy Lineberry, Arizona State University Art Museum, Tempe, March 4–June 4, 2000.

Greater New York: New Art in New York Now. P.S.1 Contemporary Art Center in collaboration with the Museum of Modern Art, New York, February 27–April 16, 2000.

The End. Exit Art/The First World, New York, January 29–April 8, 2000.

**As Far as the Eye Can See.* Atlanta College of Art Gallery, Atlanta, Ga., January 29– March 7, 2000.

Visionary Landscape. Christopher Grimes Gallery, Santa Monica, Calif., January 8– February 19, 2000.

1999

Best of the Season: Selected Work from the 1998–99 Gallery Season. Aldrich Museum of Contemporary Art, Ridgefield, Conn., September 26, 1999–January 9, 2000.

1998

Interlacings: The Craft of Contemporary Art. Whitney Museum of American Art at Champion, Stamford, Conn., September 10–November 21, 1998.

22/21. Emily Lowe Gallery, Hofstra University Museum, Hempstead, N.Y., September 8– October 25, 1998.

Elise Goodheart Fine Art, Sag Harbor, N.Y., July 24–August 16, 1998.

DNA Gallery, Provincetown, Mass., July 17–August 5, 1998.

Nine International Artists at Wanås 1998. Wanås Foundation, Knislinge, Sweden, May 24– October 18, 1998.

Landscapes. Meyerson & Nowinski, Seattle, January 8–March 1, 1998.

1997

Redefinitions: A View from Brooklyn. California State University, Fullerton, November 9–
 December 11, 1997.

9 to 5 at Metrotech: New Commissions for the Common. Public Art Fund, Brooklyn, N.Y.,
 October 30, 1997–May 31, 1998.

**Best of the Season 1996–97.* Aldrich Museum of Contemporary Art, Ridgefield, Conn.,
 September 14, 1997–January 4, 1998.

Current Undercurrent: Working in Brooklyn. Brooklyn Museum of Art, Brooklyn, N.Y., July 25,
 1997–January 25, 1998.

Sculpture. James Graham & Sons, New York, July 10–August 29, 1997.

Summer of Love. Fotouhi Cramer Gallery, New York, July 2–August 2, 1997.

Artists Respond to 2001: Space Odyssey. Williamsburg Art and Historical Society, Brooklyn,
 N.Y., June 21–July 26, 1997.

Benefit for Pat Hearn. Morris-Healy Gallery, New York, February 26–March 9, 1997.

1996

Imaginary Beings. Exit Art/The First World, New York, December 2, 1996–January 27,
 1997.

Multiples. Pierogi 2000, Brooklyn, N.Y., December 2, 1996–Janaury 15, 1997.

**Art on Paper.* Weatherspoon Art Gallery, University of North Carolina, Greensboro,
 November 12, 1996–January 21, 1997.

Inside Out. Momenta Art, Brooklyn, N.Y., September 15–October 7, 1996.

Currents in Contemporary Art. Christie's East, New York, July 22–July 31, 1996.

Inside: The Work of Art. California Center for the Arts, Escondido, June 16–October 13,
 1996.

Human/Nature. New Museum of Contemporary Art, New York, April 20–May 18, 1996.

Better Living through Chemistry. Randolph Street Gallery, Chicago, March–April 1996.

Wish You Were Here. Bronwyn Keenan Gallery, New York, March 1–30, 1996.

New York State Biennial. New York State Museum, Albany, February 8–May 26, 1996.

NY Withdrawing. Ronald Feldman Fine Arts, New York, January 13–February 17, 1996.

1995

Lookin' Good-Feelin'. 450 Broadway Gallery, New York, December 5–9, 1995.

1994

Red Windows: Benefit for the Little Red School House. Barneys, New York, November–
December 1994.

Spring Benefit. Sculpture Center, New York, April 19, 1994.

Garden of Sculptural Delights. Exit Art/The First World, New York, March 2–April 23,
1994.

Free Falling. Berlin Shafir Gallery, New York, January 22–February 19, 1994.

1993

UNTITLED (14). Ronald Feldman Fine Arts, New York, November 13–December 23, 1993.

INFLUX. Gallery 400, Chicago, November 3–December 4, 1993.

4 Walls Benefit. David Zwirner Gallery, New York, October 28–30, 1993.

Fantastic Wanderings. Cummings Art Center, New London, Conn., October 9–
November 10, 1993.

Extracts. Islip Art Museum, Islip, N.Y., August 8–September 19, 1993.

Popular Mechanics. Real Art Ways, Hartford, Conn., June 19–July 16, 1993.

Outside Possibilities '93. Rushmore Festival at Woodbury, N.Y., June 5–July 4, 1993.

**The Nature of the Machine*, Chicago Cultural Center, April 3–May 30, 1993.

Out of Town: The Williamsburg Paradigm. Krannert Art Museum, University of Illinois,
Champaign, January 22–February 28, 1993.

1992

Fever. Exit Art, New York, December 14, 1992–February 6, 1993.

1991

Group. Jimenez-Algus Gallery, Brooklyn, N.Y., September 13–October 13, 1991.

Entropy. Generator 547, New York, August 2–September, 5, 1991.

Tweeking the Human. Brand Name Damages and Minor Injury Galleries, Brooklyn, N.Y.,
June 7–31, 1991.

The Ego Show. Minor Injury, Brooklyn, N.Y., April 5–May 2, 1991.

1990

Desire and Deception. Brand Name Damages, Brooklyn, N.Y., October 9–21, 1990.

Group Show. Ridge Street Gallery, New York, September 3–26, 1990.

Roxy Paine & David Fasoldt. Brand Name Damages, Brooklyn, N.Y., March 29–April 16,
1990.

Public Collections

Crystal Bridges Museum of American Art, Bentonville, Arkansas

City of Beverly Hills, California

De Pont Museum of Contemporary Art, Tilburg, The Netherlands

Denver Art Museum, Denver, Colorado

Hirshhorn Museum and Sculpture Garden, Washington, D.C.

Il Giardino dei Lauri, Città della Pieve (PG), Italy

The Israel Museum, Jerusalem

Modern Art Museum of Fort Worth, Texas

The Museum of Modern Art, New York

National Gallery of Art Sculpture Garden, Washington, D.C.

National Gallery of Canada, Ottawa, Ontario

The Nelson-Atkins Museum of Art, Kansas City, Missouri

The New School for Social Research, New York

NMAC, Cadiz, Spain

North Carolina Museum of Art, Raleigh

Olympic Sculpture Park, Seattle Art Museum, Washington

Rose Art Museum, Brandeis University, Waltham, Massachusetts

Saint Louis Art Museum, St. Louis, Missouri

San Francisco Museum of Modern Art, California

Sheldon Memorial Art Gallery, University of Nebraska, Lincoln

Wanås Foundation, Knislinge, Sweden

Whitney Museum of American Art, New York

Bibliography

Books

Fineberg, Jonathan. *Art since 1940: Strategies of Being.* Englewood Cliffs, N.J.: Prentice Hall, 1995.

Fineberg, Jonathan. *Art since 1940: Strategies of Being.* 2nd ed. New York: Harry N. Abrams, 2000.

Heartney, Eleanor. *Roxy Paine.* New York: Prestel Publishing, 2009.

Richer, Francesa, and Matthew Rosenzweig. *No. 1: First Works by 362 Artists.* New York: D.A.P., 2006.

Robertson, Jean, and Craig McDaniel. *Themes of Contemporary Art: Visual Art after 1980.* New York: Oxford University Press, 2005.

Siegel, Katy, and Paul Mattik. *Art Works: Money.* New York: Thames & Hudson, 2005.

Skov Holt, Steven, and Mara Holt Skov. *Blobjects & Beyond: The New Fluidity in Design.* San Francisco: Chronicle, 2005.

Exhibition Publications

Ferne Nahe: Natur in der Kunst der Gegenwart (*Remote Proximity: Nature in Contemporary Art*). Edited by Volker Adolph. Bonn, Germany: Kunstmuseum Bonn, 2009.

Kunstmachinen Machinenkunst (*Art Machines Machine Art*). Edited by Katharina Dohm and Heinz Stahlhut. Frankfurt, Germany: Schirn Kunsthalle, 2007.

A Brighter Day. Edited by David Humphrey. New York: James Cohan Gallery, 2006.

Ecstasy: In and about Altered States. Edited by Lisa Mark; texts by Carolyn Christov-Bakargiev, Diedrich Diedrichsen, Chrissie Iles, Lars Bang Larsen, Midori Matsui, and Paul Schimmel. Los Angeles: Museum of Contemporary Art, 2005.

Flower Myth: Vincent van Gogh to Jeff Koons. Texts by Ernst Beyeler, Christoph Vitali, Robert Kopp, Philippe Büttner, and Ulf Küster. Riehen/Basel, Switzerland: Fondation Beyeler, 2005.

The Flower as Image. Texts by Poul Erik Tøjner and Ernst Jonas Bencard. Humlebæk, Denmark: Louisiana Museum for Moderne Kunst, 2004.

Open House: Working in Brooklyn. Introduction by Charlotta Kotik and Tumelo Mosaka. Brooklyn: Brooklyn Museum of Art, 2004.

Plop: Recent Projects of the Public Art Fund. Edited and written by Tom Eccles, Anne Wehr, and Jeffrey Kastner. New York: Public Art Fund with Merrell, 2004.

Some Trees. Edited by Paul Andriesse. Amsterdam: Andriesse, 2004.

Wanås Historia. Introduction by Marika Wachtmeister. Knislinge, Sweden: Wanås Foundation, 2004.

Intricacy: A Project by Greg Lynn FORM. Introduction by Claudia Gould; essay by Greg Lynn. Philadelphia: Institute of Contemporary Art, University of Pennsylvania, 2003.

Roxy Paine: Bluff. Edited by Anne Wehr; introduction by Susan K. Freedman and Tom Eccles. New York: Public Art Fund, 2003.

UnNaturally. Edited by Mary-Kay Lombino. New York: Independent Curators International, 2003.

Work Ethic. Edited by Helen Molesworth. University Park: Pennsylvania State University Press in collaboration with the Baltimore Museum of Art, 2003.

Roxy Paine: Second Nature. Texts by Lynn Herbert, Joseph Ketner, and Gregory Volk. Houston: Contemporary Arts Museum Houston, 2002.

01.01.01: Art in Technological Times. San Francisco: San Francisco Museum of Modern Art, 2001.

Arte y naturaleza: Montenmedio Arte Contemporaneo. Preface by Magda Bellotti; essay by Marika Wachtmeister. Cadiz, Spain: Fundación NMAC, 2001.

A Contemporary Cabinet of Curiosities: Selections from the Vicki and Kent Logan Collection. San Francisco: California College of Arts and Crafts, 2001.

Konsten på Wanås (Art at Wanås). Text by Marika Wachtmeister. Stockholm, Sweden: Byggförlaget Kultur, 2001.

Roxy Paine. Edited by Scott Rothkopf. New York: James Cohan Gallery, 2001.

Waterworks: U.S. Akvarell 2001. Foreword by Berndt Arell; introduction by Kim Levin. Skarhamn, Sweden: Nordiska Akvarellmuseet, 2001.

The Greenhouse Effect. Essays by Julia Peyton-Jones and Lisa Corrin. London: Serpentine Gallery, 2000.

Sites around the City: Art and Environment. Texts by Heather Sealy Lineberry and Ronald Jones. Tempe: Arizona State University Art Museum, 2000.

As Far as the Eye Can See. Atlanta, Ga.: Atlanta College of Art Gallery, 1999.

In vitro landscape. Edited by Christiane Paul. Koln, Germany: Buchandlung Walther Koenig in collaboration with Architektur-Galerie am Weissenhof, 1999.

22/21. Edited by Robert Morgan. Hempstead, N.Y.: Emily Lowe Gallery, Hofstra University, 1998.

Wanås 1998. Essay by Robert Storr. Knislinge, Sweden: Wanås Foundation, 1998.

Best of the Season: Selected Works from 1996–97 Gallery Exhibition. Ridgefield, Conn.:
 Aldrich Museum of Contemporary Art, 1997.

Redefinitions: A View from Brooklyn. Texts by Annie Herron and Matt Freedman. Fullerton:
 Main Art Gallery, California State University, Fullerton, 1997.

Art on Paper. Edited by Tom Kocheiser. Greensboro: Weatherspoon Art Gallery, University
 of North Carolina, 1995.

The Nature of the Machine: An Exhibition of Kinetic and Biokinetic Art. Texts by Lanny
 Silverman, Michael Lash, and Douglas Davis. Chicago: Chicago Cultural Center,
 Chicago Public Library, 1993.

Out of Town: The Williamsburg Paradigm. Edited by Jonathan David Fineberg. Champaign:
 Krannert Art Museum, University of Illinois at Urbana-Champaign, 1993.

Articles and Reviews

2010

"Welt im Stahlgewitter." *A&W Architektur & Wohnen*, December 2010–January 2011.

Fulton, Sam. "Cockatoo Island Proves the Star of the Biennale." *Sydney Morning Herald*,
 August 4, 2010.

Korek, Bettina. "Ed Schad on Roxy Paine's *Erratic*: The Newest Addition to the Beverly Hills
 Public Art Collection." *Huffington Post*, June 4, 2010.

Fortescue, Elizabeth. "Two-Tonne Nerve Centre of Biennale." *Daily Telegraph* (Sydney,
 Australia), April 28, 2010.

2009

Duponchelle, Valerie. "Miami, chronique d'une reprise annoncée." *Le Figaro*, December 5,
 2009.

The Washington Times. Metro Briefs, June 3, 2009.

"National Gallery Commissions Paine for Sculpture." *Examiner.com*, June 2, 2009.

"Roxy Paine instala un árbol gigante de metal en la azotea del Metropolitan." *El Nacional*
 (Caracas, Venezuela), April 29, 2009.

Seigel, Miranda. "The Annotated Artwork 'Maelstrom.'" *New York Magazine*, April 26,
 2009.

Johnson, Ken. "Even High atop a Roof It Reaches for the Sky." *New York Times*, April 24,
 2009.

Goings on about Town. *New Yorker*, April 20, 2009.

Shinn, Dorothy. "Explore Beauty of Science." *Akron Beacon Journal*, March 29, 2009.

Williams, Tod, and Billie Tsien. "Roxy Paine." *BOMB*, Spring 2009.

Mendelsohn, Meredith. "Roxy Paine: Ceçi N'est Pas un Arbre: The Artist's Output Is Far from Literal." *Art + Auction*, February 2009.

2008

Hsieh, Catherine Y. "Faux Naturale." *NYArts*, September 2008.

Robinson, Gaile. "Whether You See an Embrace or Conflict on the Modern's Lawn Depends on Your Eye." *Fort Worth Star Telegram*, July 21, 2008.

Vogel, Carol. "Ellsworth Kelly, Basking in Basel." *New York Times*, June 6, 2008.

Robinson, Walter. "Baselmania 2008." *Artnet*, June 5, 2008.

"Roxy Paine: Getting Back to His Roots." *Art Newspaper Art Basel Daily Edition*, June 4, 2008.

2007

Goings On about Town. *New Yorker*, August 27, 2007.

Genocchio, Benjamin. "Mad. Sq. Art 2007: Roxy Paine." *New York Times*, May 18, 2007.

Sheets, Hilarie M. "Trunk Show." *Time Out New York*, May 17, 2007.

Cohen, David. "How Green Is My Sculpture?" *New York Sun*, May 10, 2007.

2006

Vogel, Carol. "Madison Square Art." Inside Art. *New York Times*, December 1, 2006.

Neil, Jonathan T. D. "Do Androids Dream of Making Art?" *Art Review*, August 2006.

Baker, R. C. Best in Show. *Village Voice*, June 29, 2006.

Green, Tyler. "Acquisition Alert: MOCA and Roxy Paine." *Modern Art News*, May 25, 2006.

Castro, Jan Garden. "Collisions: A Conversation with Roxy Paine." *Sculpture* 25, no. 4 (May 2006).

Volk, Gregory. "Roxy Paine at James Cohan." *Art in America*, May 2006.

Hall, Emily. "Review: Roxy Paine." *Artforum*, April 2006.

Trembley, Nicolas. "Déraciné." *Numéro*, April 2006.

Yau, John. Interview with Roxy Paine. *SourceCode TV*, season 3, episode 7, April 2006.

Wolfe-Suarez. "Ecstasy: In and about Altered States." *Art Papers*, March–April 2006.

Marchini, Claudia. "Readers Talk: Rage at the Machine." *Oregonian*, March 31, 2006.

Motley, John. "Roxy Paine." *Portland Mercury*, March 22, 2006.

Row, D. K. "Jackson Pollock, Meet 'PMU.'" *Oregonian*, March 5, 2006.

Lowenstein, Kate. "Roxy Paine at James Cohan." *Time Out New York*, February 23, 2006.

Wright, Karen. "Roxy Paine at James Cohan." *Modern Painters*, February 2006.

"Roxy Paine," *MoCA at the Moment*, Winter/Spring 2006.

Sung, Ellen. "Look Who's Coming: Jonathan Fineberg, Ph.D." Interview with Jonathan Fineberg. *News & Observer*, January 31, 2006, http://www.newsobserver.com /105/story/394330.html.

Johnson, Ken. "Roxy Paine." *New York Times*, January 27, 2006. Arts and Letters section.

Cohen, David. "Theaters of the Absurd." *New York Sun*, January 19, 2006.

Peters, Sue. "Sculpting Controversy." *Seattle Weekly*, January 18, 2006.

Ribas, João. The AI Interview. Interview with Roxy Paine. *Artinfo.com*, January 13, 2006, http://www.artinfo.com/news/story/9448/roxy-paine/.

Davis, Erik. "Ecstasy: In and about Altered States." *Artforum*, January 2006.

McCarthy, John. "Roxy Paine in Ponderland." *Art and Living*, January 2006.

2005

Kimmelman, Michael. "A Mind-Bending Head Trip (All Legal)." *New York Times*, November 4, 2005, Weekend Arts section.

Casadio, Mariuccia. "Grow a Mushroom." *Vogue Italia*, August 2005.

Baker, R. C. "Decaying Pixels." *Village Voice*, June 1, 2005.

———. "Outdoor Sculpture Gains Media Acclaim." *Saint Louis Art Museum Magazine*, April 2005.

2004

Weinberg, Michelle. "Get Unreal." *Miami New Times*, October 21, 2004.

Robinson, Walter. Weekend Update. *Artnet.com*, September 17, 2004, http://www.artnet .com/magazine/reviews/walrobinson/robinson9-17-04.asp.

Bonetti, David. "The 'Placebo' Effect." *St. Louis Post-Dispatch*, September 5, 2004.

MacMillan, Kyle. "Art Unchained Graces Aspen." *Denver Post*, August 27, 2004.

Wolgamott, L. Kent. "Artist Goes Once More unto the 'Breach.'" *Lincoln Journal Star*, June 13, 2004.

Giles, Gretchen. "Natural Fool." *North Bay Bohemian*, April 28, 2004.

Hassebroek, Ashley. "Sculpture Takes Root at Sheldon." *Omaha World Herald*, April 23, 2004.

Wenz, John. "Tree Sculpture Brings Typical Art Environment Outdoors." *Daily Nebraskan*, April 22, 2004.

Wolgamott, L. Kent. "New Sculpture Branches Out." *Lincoln Journal-Star*, April 21, 2004.

Moseman, Andrew. "Metallic Tree Look-alike Takes Root on Campus." *Daily Nebraskan*,
April 16, 2004.

Hassebroek, Ashley. "Sheldon Adds a 21st Century Sculpture." *Omaha World-Herald*,
April 4, 2004.

Pagel, David. "Reality and Irony Collide." Art review. *Los Angeles Times*, January 2, 2004.

2003

Lafuente, Pablo. "8th International Istanbul Biennial." *Art Monthly*, November 2003.

Van Malsen, Annemarie. "Koud Kunstje." *Brabants Dagblad* (Den Bosch, The Netherlands),
October 28, 2003.

Gopnik, Blake. "Redefining Art? They Managed." *Washington Post*, October 19, 2003.

O'Sullivan, Michael. "BMA Tests Audience's 'Work Ethic.'" *Washington Post*, October 17,
2003.

McNatt, Glenn, and Mary Carole McCauley. "Pass the Art, Please." *Baltimore Sun*,
October 13, 2003.

"Work Ethic: Baltimore." Review. *Flash Art* 36, no. 232 (October 2003): 44.

"Botanische vormen." Review. *Volkskrant* (Amsterdam, The Netherlands), September 18,
2003.

Schoonen, Rob. "'Ik hou van tegenstellingen." *Brabants Dagblad* (Den Bosch, The
Netherlands), September 18, 2003.

Smith, Roberta. "Washington's Museums Traverse Miles and Eras." Art Review. *New York
Times*, August 22, 2003.

Wilson, Peter. "Intersections: Art and New York Green." *Paper Sky* 6, no. 6 (Summer 2003):
53.

Bennett, Lennie. "Fooling around with Mother Nature." *St. Petersburg Times*, January 26,
2003.

Hu, Li. "Timecode." *32 Beijing/New York*, no. 2 (2003): 6–9.

2002

Klaasmeyer, Kelly. "Nature vs. Nurture: Roxy Paine Turns Fake Flowers and Painting
Machines into High Art." *HoustonPress.com*, December 5, 2002, http://www
.houstonpress.com/2002-12-05/culture/nature-vs-nurture/.

Exhibits. "'Roxy Paine/Second Nature' at the Contemporary Arts Museum in Houston, TX."
Dwell, December 2002, 98.

Madoff, Steven Henry. "Nature vs. Machines? There's No Need to Choose." *New York
Times*, June 9, 2002.

"Roxy Paine at Bernard Toale Gallery, Boston." *Week*, May 10, 2002.

McQuaid, Cate. "A Striking Show at the Rose Museum Explores Art in the Machine." *Boston Globe*, May 7, 2002.

Giuliano, Charles. "Narcotics and Robotics: The Post Mechanical Duality of Roxy Paine." *East Boston Online*, April 28, 2002, http://www.eastboston.com/Columnists /CharlesG/042802MavArts.htm.

Schmidt, Jason. "Outsider Art." *V Magazine*, March–April 2002.

Henry, Clare. "The Art of Listening Carefully." *Financial Times* (London), March 27, 2002.

"Happening; Museum Parking." *New York*, March 18, 2002.

Bischoff, Dan. "Moving Images." *Star Ledger*, March 7, 2002.

Gardner, James. "Witless Whitney." *New York Post*, March 7, 2002.

Robinson, Walter. Weekend Update. *Artnet.com*, March 7, 2002, http://www.artnet .com/Magazine/reviews/robinson/robinson3-7-02.asp.

Schoeneman, Deborah. "Gallery on Grass, Take a Sculpture Hike through Central Park." *New York Post*, March 7, 2002.

Budick, Ariella. "Pieces of the Biennial Take to the Park." *Newsday* (New York), March 6, 2002.

Plagens, Peter. "This Man Will Decide What Art Is." *Newsweek*, March 4, 2002.

McGee, Celia. "A Breath of Fresh Air." *Daily News*, March 3, 2002.

Vogel, Carol. "Sometimes, Man Can Make a Tree." *New York Times*, February 27, 2002.

Griffin, Tim. "Bi Curious." *Time Out New York*, February 21, 2002.

2001

Vogel, Carol. "A Homegrown Biennial." *New York Times*, November 16, 2001.

Hammond, Anna. "Roxy Paine at James Cohan." *Art in America*, September 2001.

Iannaccone, Carmine. "Roxy Paine at Christopher Grimes Gallery." *Frieze*, September 2001.

Thorson, Alice. "Art Machines That Make Big Decisions." *Kansas City Star*, July 29, 2001.

Molina, Margot. "El sueño de un bosque de verano." *El País* (Madrid), June 23, 2001.

Sichel, Berta. "El arte interviene en el paisaje." *El Periódico del Arte* (Barcelona), June 20, 2001.

Knight, Christopher. "Roxy Paine." *Los Angeles Times*, June 15, 2001.

"Naturaleza en el nuevo Museo de Montenmideo." *El País* (Madrid), June 6, 2001.

Bonetti, David. "High on Tech." *San Francisco Chronicle Datebook*, June 3, 2001.

Gonzalez, Maria. "Arte en Liberato." *Ideal*, June 3, 2001.

Werthem, Margaret. "Worlds Apart." *LA Weekly*, May 18, 2001.

Goldberg, David. "'01.01.01: Art in Technological Times' at SFMOMA." *Artweek*, May 2001.

Rogina, Kresimir. "Izlozaba '01.01.01.'" *Croatian Daily* (Zagreb), May 2001.

Yablonsky, Linda. "Roxy Paine: New Work." *Time Out New York*, April 26, 2001.

Levin, Kim. Voice Choices. *Village Voice*, April 24, 2001.

"Roxy Paine." Review. *New Yorker*, April 23, 2001.

Hand, Eric. "SF MOMA's '01.01.01': Digital Art for Analog People." *Stanford Daily*, April 12, 2001.

Sheets, Hilarie. "Spring Art Walk." *New York Observer*, April 2, 2001.

Rugoff, Ralph. "Virtual Corridors of Power." *Financial Times* (London), March 31, 2001.

Gonzalez-Barba, Andres. "Nueve artistas exponen sus obras en plena redacción, 'La Primera E Sculptura En Montenmideo.'" *Diario de Cadiz*, March 23, 2001.

Muchnic, Suzanne. "Museum Chief." *Los Angeles Times*, March 18, 2001.

Landi, Ann. "The Big Dipper." *ARTnews*, January 2001.

2000

Johnson, Ken. "Extra Ordinary." *New York Times*, June 9, 2000.

Staple, Polly. "The Greenhouse Effect." *Art Monthly*, May 2000.

Tumlir, Jan. "The Visionary Landscape." *Frieze*, May 2000.

Searle, Adrian. "Stuck in the Woods." *Guardian*, April 4, 2000.

Cambell, Clayton. "The Visionary Landscape." *Flash Art*, March–April 2000.

Saltz, Jerry. "Greater Expectations." *Village Voice*, March 14, 2000.

Heiss, Alanna. "Greater New York." *NY Arts*, March 2000.

Nordlinger, Pia. "Double Dipping." *ARTnews*, March 2000.

O'Connel, Kim. "Fungus among Us." *Landscape Architecture*, March 2000.

1999

Nahas, Dominique. "Roxy Paine." *Flash Art* 32 (May–June 1999): 114–15.

Lin, Tan. "Fungi of False Reproduction." *ArtByte* 2, no. 1 (April–May 1999): 64.

Klein, Mason. "Roxy Paine." *Artforum*, April 1999.

Weil, Rex. "Roxy Paine." *ARTnews*, April 1999.

Kjellgren, Thomas. "Tillbaka till naturen: Roxy Paines omsorfgsfulla lekfullhet smittar." *Hallandsposten* (Halmsted, Sweden), March 26, 1999.

Jonsson, Dan. "Tur och retur till naturen." *Express* (Malmö, Sweden), March 25, 1999.

Kjellgren, Thomas. "Under ytans ordning finns det okontrollerbara." *Kristianstedsbladet* (Kristiansted, Sweden), March 25, 1999.

Ellerstrom, Jonas. "Drogromantik eller kulturkritik?" *Helsingborgs Dagblad* (Helsingborg, Sweden), March 22, 1999.

Klinthage Lorgen. "Vart behov att beharska naturen." *Arbetet Nyheterna* (Malmö, Sweden), March 22, 1999.

Malmqvist, Conny C-A. "Roxy Paine gorett konststycke. . . ." *Kvallsposten* (Malmö, Sweden), March 16, 1999.

Strom, Eva. "Nice Flowers with Chilly Undertone." *Svenska Dagbladet* (Stockholm, Sweden), March 13, 1999.

Kyander, Pontus. "Art Gallery Filled with Unnature." *Sydsvenskan* (Malmö, Sweden), March 9, 1999.

Billgren, Cecilia. "Utvecklingsstord lamnades ensam." *Arbetet Nyheterna* (Malmö, Sweden), March 6, 1999.

Hall, Kim. "Brooklyn-komstnar pa Lunds konsthall." *Skanska Dagbladet* (Malmö, Sweden), March 6, 1999.

Nordstrom, Nicklas. "2000 svampar ger eftertanke." *Lund Langlordag* (Lund, Sweden), March 6, 1999.

Bakke, Erik, and Shelley Ward. "Mob Rule: Sculpture after Hanson." *NY Arts*, March 1999.

Burrows, David. "Dunkin' Donuts." *Art Monthly*, March 1999.

Kino, Carol. "Roxy Paine." *Time Out New York*, February 4, 1999.

Maxell, Douglas. "Roxy Paine." *Review*, 4.9, February 1, 1999.

Multer, Mario. "Roxy Paine." *Review*, 4.9, February 1, 1999.

"Roxy Paine," *New Yorker*, February 1, 1999.

Pedersen, Victoria. Gallery Go 'Round. *Paper Magazine*, February 1999.

Pinchbeck, Danie. "Our Choice of Contemporary Galleries in New York." *Art Newspaper*, February 1999.

Levin, Kim. "Roxy Paine." *Village Voice*, January 26, 1999.

Henry, Max. Gotham Dispatch. *Artnet*, January 15, 1999, http://www.artnet.com /magazine_pre2000/reviews/henry/henry1-15-99.asp.

Johnson, Ken. "Roxy Paine." *New York Times*, January 15, 1999.

Levin, Kim. "Roxy Paine." *Village Voice*, January 12, 1999.

Bakke, Eric. Studio Visit. *NY Arts*, January 1999.

Lautman, Victoria. "No Weeding Necessary." *Interview*, January 1999.

Schwabsky, Barry. "Surrounded by Sculpture." *Art in America*, January 1999.

"Roxy Paine." *Simon Says* 3, no. 6 (1999).

1998

Cooney, Beth. "The Craft of Art." *Advocate & Greenwich Time*, October 11, 1998.

Zimmer, William. "Seven Artists Apply Craft to Fine Art." *New York Times*, October 11, 1998.

Frey, Jennifer. "Lacing Art and Craft into One Form." *Weekend*, September 10, 1998.

Gignoux, Sabina. "Les jeux ambigus d'une naturelle inspiration." *La Croix* (Saint-Ananje, France), August 1998.

Lind, Ingela. "Naturen som hot." *Dagens Nyheter* (Stockholm, Sweden), July 30, 1998.

"Les champs de Roxy Paine." *La Dépêche d'Evreux* (Evreux, France), July 2, 1998.

"Champs artificiels et machine à peindre au musée d'art américain de Giverny." *Le Democrata* (France), July 1, 1998.

Schon, Margaretha. "Med freestyle och insiders I Wanås Walk." *Svenska Dagbladet* (Stockholm, Sweden), June 13, 1998.

Ahistrom, Crispin. "Intelligenta naturlekar." *Goteborgs-Posten* (Goteborg, Sweden), June 5, 1998.

Kyander, Pontus. "Elegant och intelligent." *Sydsvenskan* (Malmö, Sweden), May 27, 1998.

J. K. "An Opium Field – Deceptively Natural." *Kölner City-Observer* (Cologne, Germany), May 14, 1998.

"In the Public Realm." *Inprocess* 6, no. 3 (Spring 1998): 5.

Fredericksen, Eric. "Landscapes and Suburbs: Beyond Nature." *Stranger*, February 5, 1998.

"Paper Trail." *On Paper* 2, no. 3 (January–February 1998).

Glueck, Grace. "A Chair, a Fireplace, Binoculars: Sculpture to Be Seen on the Street." *New York Times*, January 16, 1998.

Updike, Robin. "Beyond Pretty Scenery." *Seattle Times*, January 15, 1998.

Bonetti, David. "What It Is 'To BE Real.'" *San Francisco Examiner*, January 12, 1998.

Hackett, Regina. "Warmth and Romance Prove Elusive in Meyerson & Nowinski's 'Landscape.'" *Seattle Post-Intelligencer*, January 9, 1998.

Costa, Eduardo. "Crafty Contemporanea," Artnet.com, 1998, http://www.artnet.com/magazine/reviews/costa.

1997

Baker, Kenneth. "When Reality Is Just Another Medium." *San Francisco Chronicle Datebook*, December 23, 1997.

Pollack, Barbara. "Buying Smart: Top Collectors Share Their Secrets." *ARTnews*, December 1997.

"Aldrich Gives Award to 'Emerging' Artist." *Ridgefield (Conn.) Press*, October 23, 1997.

Chaiklin, Amy. Studio Visits. *NY Arts*, October 1997.

Nassau, Lawrence. "Current Undercurrent: Working in Brooklyn." *NY Arts*, October 1997.

"Best Do-It-Yourself Art Kits: Roxy Paine." Best of Manhattan. *NY Press*, September 24, 1997.

Arning, Bill. "Brooklyn in the House." *Village Voice*, August 26, 1997.

Dalton, Jennifer. "Just What Do You Think You're Doing Dave?" *Review* 2, no. 19 (July–August 1997): 20.

Schmerler, Sarah. "Last Exit to Brooklyn." *Time Out New York*, July 31, 1997.

Gibson, David. "Roxy Paine: Dunk/Redunk; Ronald Feldman Fine Arts." *Zingmagazine*, no. 4 (Summer 1997): 249–50.

Levin, Kim. Voice Choices. *Village Voice*, April 8, 1997.

Smith, Roberta. "Roxy Paine." *New York Times*, April 4, 1997.

Dellolio, Peter. "Roxy Paine." *New York Soho*, April 1997.

Pedersen, Victoria. Gallery Go 'Round. *Paper Magazine*, April 1997.

1996

Smith, Roberta. Inside/Out. *New York Times*, September 20, 1996.

Levin, Kim. Voice Choices. *Village Voice*, March 12, 1996.

1995

Check It Out. *Print Collector's Newsletter* 26, no. 5 (November–December 1995): 177.

Humphrey, Jacqueline. "Art on Paper Acquisitions Reflect a New Weatherspoon." *Greensboro News & Record*, November 17, 1995.

Heartney, Eleanor. "Roxy Paine at Ronald Feldman." *Art in America*, November 1995.

Light, Flash. "The Neo-Kinetic Closet." *Movements* 4, no. 1 (Fall 1995): 1–11.

Paine, Roxy. "Sacraments for a High Priest." *Harper's*, July 1995.

Hess, Elizabeth. "Cross Hatching." *Village Voice*, May 16, 1995.

Levin, Kim. Voice Choices. *Village Voice*, May 16, 1995.

Clarke, Donna. "Chowing with Mao." *New York Post*, May 1, 1995.

Drucker, Johanna. "The Next Body: Displacements, Extensions, Relations." *Les Cahiers du Musée National d'Art Modern* (Paris). Spring 1995.

1994

"1993 in Review: Alternative Spaces." *Art in America*, August 1994.

Levin, Kim. Voice Choices. *Village Voice*, April 5, 1994.

Wallach, Amei. "An Exuberant Celebration of Life." *Newsday* (New York), April 1, 1994.

Larson, Kay. "The Garden of Sculptural Delights." *New York*, March 28, 1994.

Hicks, Robert. "Group Seeks to Wed Sculpture and Theater." *Villager*, March 23, 1994.

1993

Hess, Elizabeth. "Give Me Fever." *Village Voice*, December 29, 1993.

Smith, Roberta. "Examining Culture through Its Castoffs." *New York Times*, November 28, 1993.

Robinson, Julia. "Flesh Art." *World Art*, November 1993.

Bulka, Michael. "The Nature of the Machine." *New Art Examiner*, September 1993.

Zimmer, William. "How Physics Is Raised to Metaphysics in a Real Art Ways Show in Hartford." *New York Times*, July 4, 1993.

1992

Kimmelman, Michael. "Promising Start at a New Location." *New York Times*, December 18, 1992.

Egert, Robert. "Roxy Paine at Test-Site." *Breukelen* 1 (January 1992).

1991

Sellers, Terry. Review. *Artist Proof*, Fall 1991, 4–6.

1990

Blake, Kit. Review. *Word of Mouth*, September 1990.

Permissions and Photo Credits